THEN *&* NOW®

WESTERVILLE

OPPOSITE: This view of College Avenue looking west toward Vine Street was captured between 1900 and 1910, near what is today Ben Hanby Park. (Author's collection.)

THEN & NOW®

WESTERVILLE

Nathaniel Richard Baker

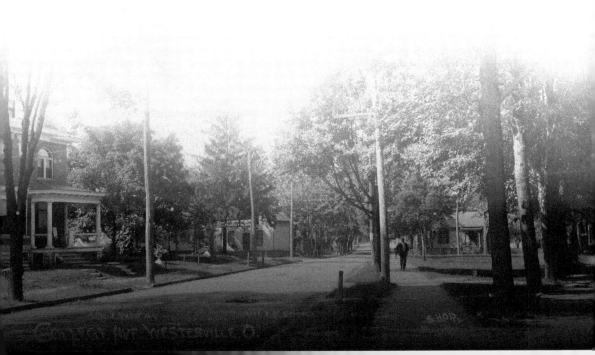

To my family:

My wife, Lindsay—thank you for supporting my passion, dedication, and love for Westerville history.

My parents, Cory and Laurie—without your loving support, prayers, and encouragement, this book wouldn't have been completed.

And my grandparents, Richard (1928–2008) and Linda Siegel and Peter (1924–1978) and Mardelle Baker—thank you for instilling within me a sense of preservation for history and seeing the true importance behind it.

Copyright © 2018 by Nathaniel Richard Baker
ISBN 9781540228307

Library of Congress Control Number: 2017959244

Published by Arcadia Publishing
Charleston, South Carolina

Then and Now is a registered trademark and is used under license from Salamander Books Limited

For all general information, please contact Arcadia Publishing:
Telephone 843-853-2070
Fax 843-853-0044
E-mail sales@arcadiapublishing.com
For customer service and orders:
Toll-Free 1-888-313-2665

Visit us on the Internet at www.arcadiapublishing.com

ON THE FRONT COVER: This iconic view of "Uptown" Westerville shows State Route 3, looking south at the corner of Main Street. Freight interurban No. 374, is seen in the 1906 photograph as it makes a stop at the corner of College Avenue on its way north while villagers go about their daily lives. The Holmes Block is found on the right, and the Weyant Block, now the Old Bag of Nails restaurant, is on the left. Today, this intersection is one of the busiest in town, with thousands of cars passing daily. (Both, author's collection.)

ON THE BACK COVER: The Cleveland, Akron & Columbus Railroad station in Westerville was constructed in 1873 with great anticipation from the village residents. This view from around 1900 shows the Bennett Manufacturing Company in the background. (Author's collection.)

CONTENTS

ACKNOWLEDGMENTS

Thank you to my brother Andy, sister-in-law Jen, and my mother and father, Laurie and Cory, for proofreading this book. I would like to thank the Westerville Public Library and the Local History Center at the Westerville Public Library for granting the public with access to documents, census records, books, and newspapers that tell the full story of Westerville. Without the help of Beth Weinhardt and Nina Thomas, this book would not have been possible.

Unless otherwise noted, all images appear courtesy of the author's collection.

INTRODUCTION

Westerville, Ohio, was platted in 1839 on land given by Peter and Matthew Westervelt; the land was divided into village lots and an educational institution. While most towns were formed around rivers, railroads, and harbors, Westerville was organized around a Methodist institution. In 1838, a large camp meeting for the Methodist denomination occurred near the present site of Towers Hall on Otterbein's campus. During this meeting, it was decided to construct an educational institution. Matthew Westervelt gave eight acres for its formation, and the school became known as Blendon Young Men's Seminary. Organized on February 9, 1839, it was hoped that the school would prosper and become the leading college for western Methodism. The school was forced to close in 1844 from competition with Ohio Wesleyan University in Delaware, Ohio, having been founded in 1842. By 1847, the land was sold to the United Brethren Church at debt cost.

Garrit and Anna (Goodspeed) Sharp arrived from New York in 1810, settling on 118 acres near the area of Old County Line Road and State Street; the land eventually grew to 450 acres. Garrit Sharp named the area Sharp's Settlement; the name did not last. The village was renamed Westerville in 1839 when Peter and Matthew Westervelt gave 19 acres to be sold as individual lots in what is now the area of College Avenue, Grove Street, Main Street, and State Street. During the same year, a post office was established. The settlement was incorporated as a village on July 19, 1858, when a petition was signed by 87 residents requesting such action. The first ordinance was passed in December 1858, which forbade immoral, indecent, and improper practices and also prohibited "reckless driving and racing [horses] in the streets."

During the following year, an ordinance was passed prohibiting the "sale, barter or gift of wine, fermented cider, beer, and spirituous liquors." By 1875, however, the ordinance was not being enforced when Corbin's Saloon opened on the corner of Knox and Main Streets. Much to the disapproval of the townspeople, the saloon was dynamited; to this day, no record or conviction as to who participated in the explosion has been found.

Henry Corbin, unwilling to give up, purchased a hotel on State Street in 1879 and once again ran a saloon. On September 15, around 2:00 a.m., the frame structure, which housed the hotel, proved no match for another round of dynamite, and the building was completely destroyed. Rumors began circulating that five men had been seen running from the hotel just before the explosion. Some townspeople suspected that Henry Corbin was guilty since no one was seriously injured and the rugs from the front rooms had been rolled and stored away. Corbin's son had also supposedly mentioned that the family was in the backyard at the time of the explosion. Corbin was tried for malicious destruction of his own property in mayor's court, but he was not found guilty. This would mark the end of the "Westerville Whiskey Wars."

The Whiskey Wars became a contributing factor when the Anti-Saloon League of America (ASLA) was looking for a new location for their national headquarters. The Anti-Saloon League of America was founded in Washington, DC, through the merge of the Anti-Saloon League and the Ohio Anti-Saloon League on December 18, 1895. Howard Hyde Russell was named as the first superintendent, with the league's motto being "The

saloon must go." As the League grew, the organization looked for a location in which to consolidate its operations. Once Westerville heard about the search, townspeople raised money to purchase land where the Westerville Public Library now sits. The Anti-Saloon League accepted Westerville's offer of land and officially moved its entire operation to the village on February 12, 1909.

Upon the arrival of the Anti-Saloon League leaders, Westerville celebrated with the unified ringing of church and school bells and large bonfires during the evenings. The mayor of Westerville wrote a letter to the league, saying, "We are not able to welcome you as largely financially as some other villages would, but you will find that our hearts are larger than our pocketbooks. With our proximity to the State Capital, we have none of the corresponding high rents, high-priced real estate, and places of vice and immorality." The league settled into their 10-acre site and quickly began its operations. By 1916, about 40 tons of anti-alcohol material was being mailed around the country. The large volume of material pushed the Westerville Post Office to a first-class status, making it the smallest town in the United States to hold a first-class post office. The league rejoiced in the passing of the 18th Amendment, which forbade the sale of alcohol nationwide. This, however, was repealed by the 21st Amendment in 1933. The Anti-Saloon League began losing the battle against alcohol, and by the end of 1934, the league merged with the Word League Against Alcoholism and was restructured as the Temperance Education Foundation. Headquarters for the foundation remained in Westerville until 1973.

In 1853, Bishop William Hanby and his wife, Ann, moved into Westerville; both William and Ann were avid abolitionists. Having only a few months of formal education, William wished for his children to benefit from college instruction. William and Ann's eldest son, Benjamin, enrolled at Otterbein and was very interested in music and ministry work. Ben loved children and enjoyed writing songs to help teach the students their lessons. He taught on and off for several years as a way to earn money to graduate. Thus, in 1858, Ben graduated from Otterbein with honors and was married to Kate Winter the day after graduation.

While attending the 1856 school year, Ben wrote "Darling Nelly Gray," which would become one of his most famous compositions, along with "Up on the House Top." "Darling Nelly Gray" tells the story of Joe Selby, a runaway slave who met the Hanby family near Rushville, Ohio, in 1842. At the time Selby reached the Hanby's home, his health was failing, and he was quite weak. He told the family of his determination to reach Canada, find work, and eventually make his way south to buy the freedom of his sweetheart. Selby passed away and is buried in Rushville.

The song describes how Selby and Nelly Gray were owned by two adjacent property owners. The first two verses tell of the love between both Joe and Nelly. The third verse explains Joe's shock when he went to visit her one night and found that she had been sold and moved to Georgia. The final verse talks about how Selby and Gray are reunited in heaven as the "angels clear the way, Farewell to the old Kentucky shore."

Today, even though Westerville's population has grown to over 38,000 people, it still preserves its small-town "quiet peaceful village" atmosphere. Our founders laid the groundwork, which continues to offer extraordinary opportunity to Westerville families both old and new. The early struggles, hardships, and great efforts of our ancestors are to be recognized. From their selfless hearts and God-driven labors, Westerville has generated a community where future possibilities are endless.

IN AND AROUND
TOWN

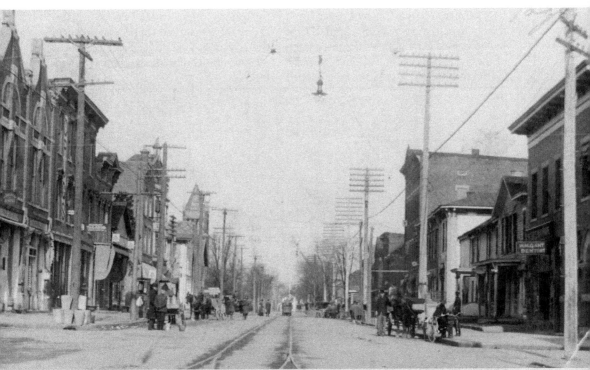

Composed by Dr. Glen and Celia Grabill in 1918, the Otterbein Love Song was greatly inspired by the village surroundings Otterbein was built: "In a quiet peaceful village, there is one we love so true. She ever gives a welcome to her friends both old and new. She stands serene, 'mid tree tops green; she's our dear Otterbein."

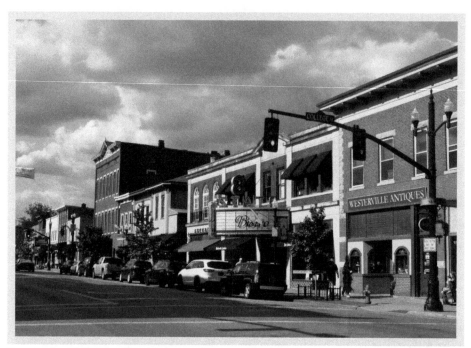

During the 1920s, the Westerville Business District, now known as Uptown, experienced few changes in the way of appearance. One building of excitement was the construction of the State Theatre in 1927, known as the Curfman Block. The theatre was equipped for silent films, including a Cleveland Symphony pipe organ. Two years later, the theatre installed sound equipment at the cost of $11,000. The State continued showing movies until the last film was shown in 1973.

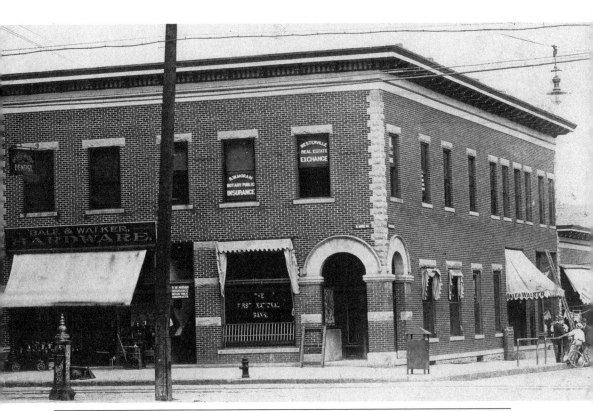

The property at 2–4 North State Street was completed in 1905 and housed the First National Bank (right), and the W.C. Bale Hardware Store (left). In 1929, First National Bank and The Bank of Westerville merged; this allowed Bale & Walker Hardware to occupy both first floor storerooms. When this c. 1913 photograph was captured, R.W. Moran Insurance and Realty, and Spies and Bale Real Estate occupied the second floor.

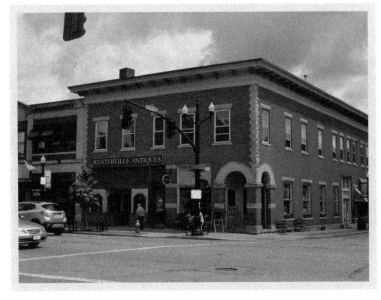

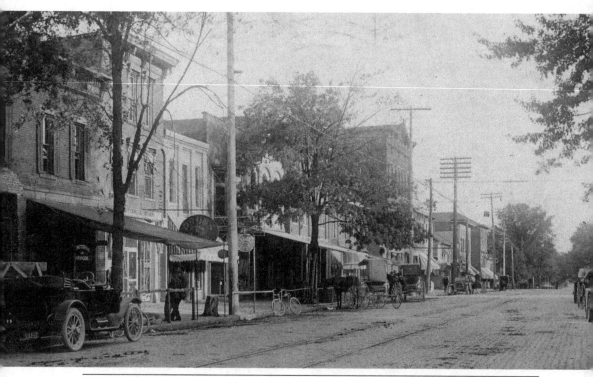

During the 1920s, Westerville was a prospering village with 2,480 residents. It was a friendly and pleasant place in which citizens still knew one another very well. Automobile quickly became the preferred method of transportation over the interurban and steam railroads. The completion of the 3-C highway connecting Cleveland, Columbus, and Cincinnati in 1924 allowed for easier travel to and from Columbus 12 miles to the south. (Above, from the Westerville History Center collection.)

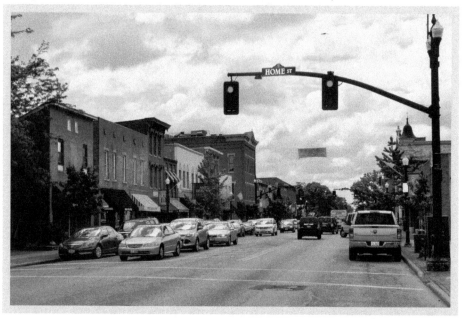

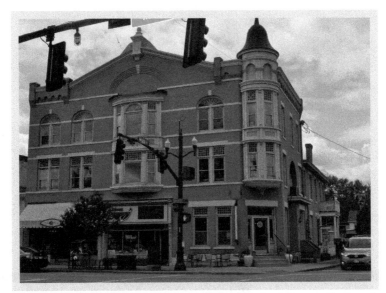

The Holmes Hotel was built by Thomas Holmes in 1889–1890 at a cost of $18,600 and was completed April 1, 1890. The Queen Anne–style structure held 30 guest rooms, a barbershop, a tailor shop, and a livery stable and blacksmith behind. On April 24, the Westerville Board of Trade held a formal opening in the dining room with 150 guests; some traveled from as far as Chicago and New Orleans to participate. The hotel claimed to be central Ohio's most magnificent new hotel.

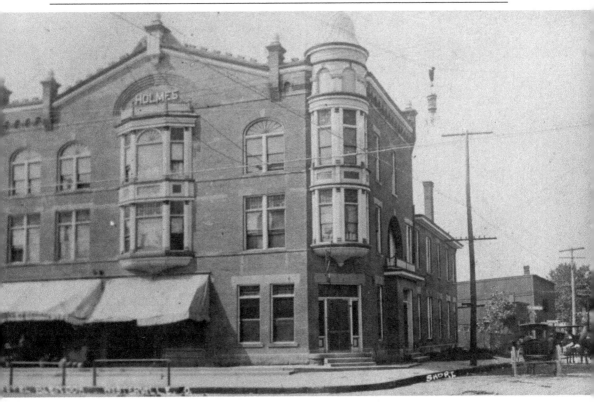

As a newer structure to the Uptown business district, 30 North State Street housed Isaly's Dairy Store until 1967. On an 1875 plat map, this lot is shown as a private residence owned by the Arnold family. During the early years of the 1900s, the frame house was replaced by a two-story redbrick building, which held a harness shop, bicycle shops, groceries, jewelers, barbershops, and two restaurants. Isaly's replaced the older building in 1941.

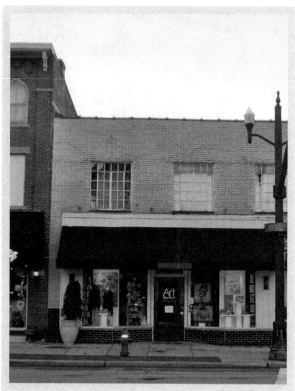

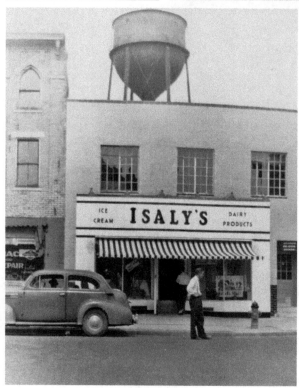

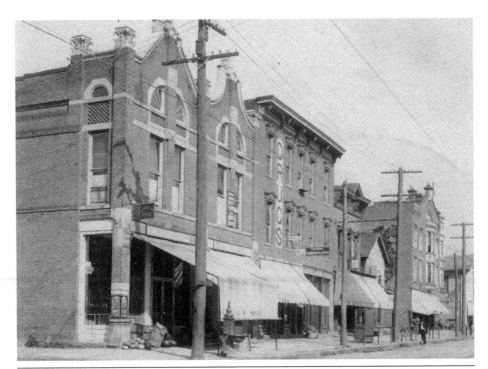

The Markley Block, seen on the left, was constructed in 1886 and served as Markley's Department Store until 1913. The building now houses Graeter's Ice Cream. In 1856, this lot served as a grocery store and post office in what was said to be the first frame house constructed in town. The next building to the north is 7–9 State Street, known as the Rowe Block. This building was constructed in 1878 and is occupied by Koble Restaurant with apartments upstairs.

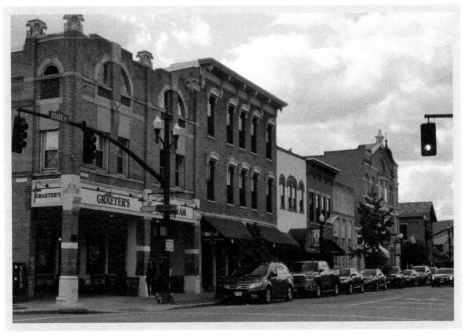

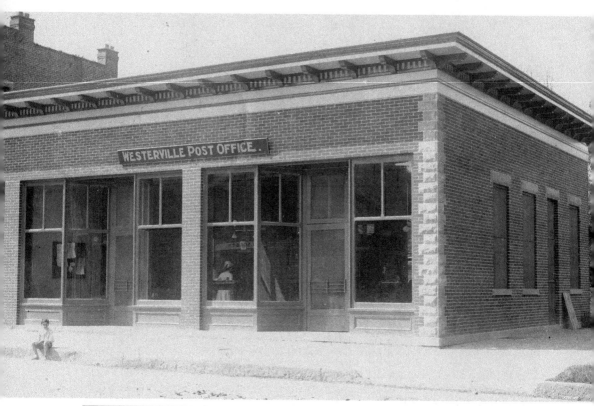

The first post office for Westerville was established in 1840, with James Connelly serving as postmaster. It was suggested the post office be named Westerville in honor of the many families in the community by the name of Westervelt. During the 1900s, the post office was located at 14 East College Avenue, seen here. Other nearby post offices included Central College, established in 1841, and Blendon Four-Corners, at the intersection of State Route 3 and 161.

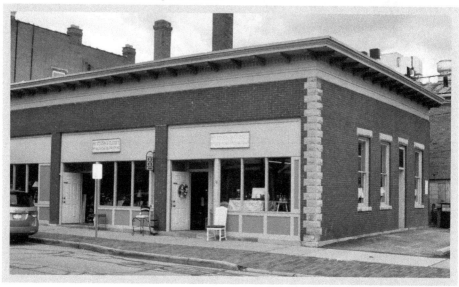

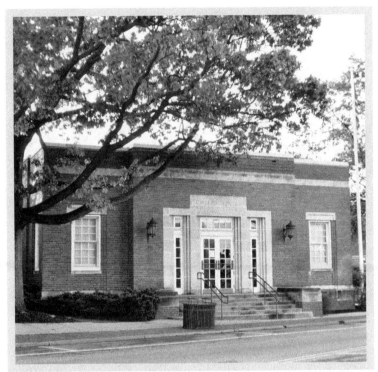

With the relocation of the Anti-Saloon League of America's national headquarters to Westerville in 1909, the post office became very busy. The ASLA relied heavily on the post office to disperse literature throughout the country, and by 1916, Westerville became the smallest community in America to have a first-class post office. Due to large processing of mail, the post office was relocated to a new and larger facility at 28 South State Street. This building remained as the post office until 1982.

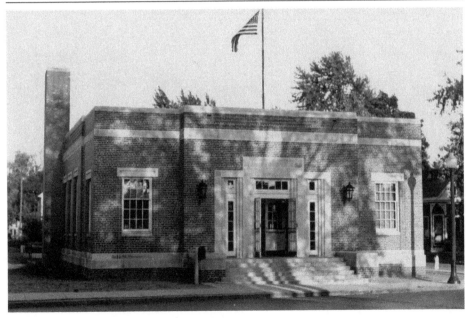

Road conditions during the late 1800s were considered deplorable, muddy, and hard to navigate. A humorous-minded Otterbein student wrote, "Oh! The streets, the Westerville streets; reviled alike by whomever one meets, covered with mud ten inches thick, into which all are likely to stick." The residents pushed for action, and in 1903, work began on paving roadways with brick. By 1910, all the main roads in town were paved.

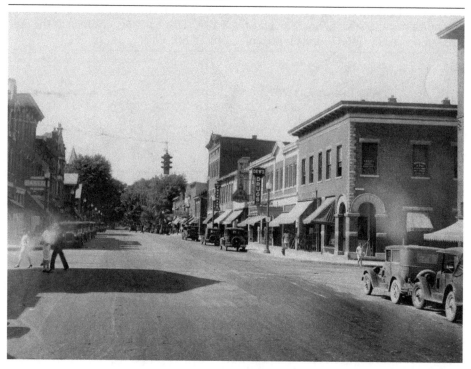

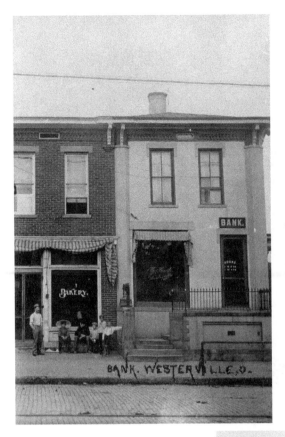

The Bank of Westerville, organized in 1883, occupied 18 North State Street until 1913, when it relocated to its newly built structure across the street at 17 North State Street. On December 18, 1930, tellers and citizens were forced to the ground as two armed men, thought to have traveled from Columbus, got away with $6,529. Both criminals were later captured—one in Columbus and one in California. Both were sentenced to life imprisonment.

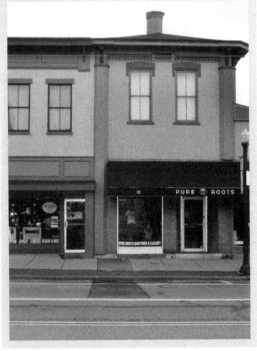

Constructed in 1881, the Weyant Block currently houses the Old Bag of Nails Pub. The Weyant Block has also served grocery stores, Bell Telephone, Westerville Taxi, Western Union Telegraph, and an opera house and skating rink on the third floor. On May 17, 1886, a production of *Uncle Tom's Cabin* was taking place when an actor accidentally kicked over a gasoline stage light. A fire broke out and the audience panicked, resulting in three deaths, including two nine-year-old children. (Right, from the Westerville History Center collection.)

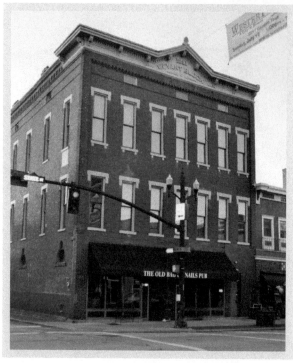

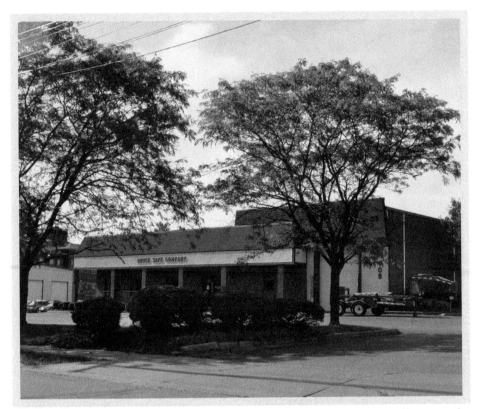

Founded by William Bassett Johnson on September 13, 1900, the Westerville Creamery once stood at 131 East Home Street. By the mid-1950s, the Westerville company owned production centers in Covington, Prospect, and Belle Center.

The first creamery in Westerville was on the southeast corner of Cleveland Avenue and Main Street. Built around 1877, the creamery was owned by Joe and Link Markley and lasted about a year and a half.

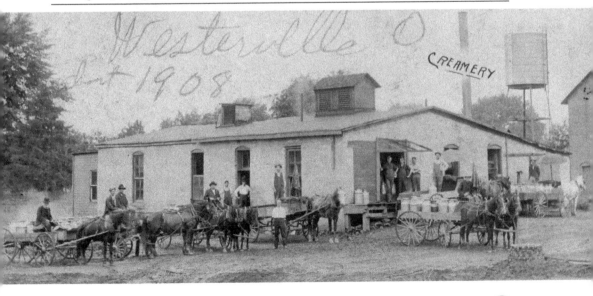

Westerville Farmers Exchange was founded in 1920 through the purchase of Burrer's Flour Milling Company, photographed here around 1914. The purchase was made possible by the collaborative efforts of 130 farmers. During the 1940s, airplane travel from Columbus to Cleveland occurred daily.

To assist pilots' navigation, the exchange painted "WESTERVILLE" in large letters on the roof. Mandy Clark of 88 South State Street was the first home owner to buy insurance against possible air damage from the planes overhead.

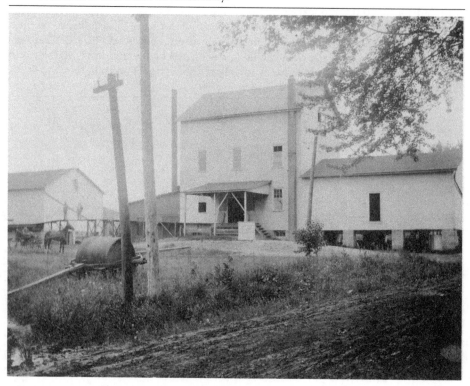

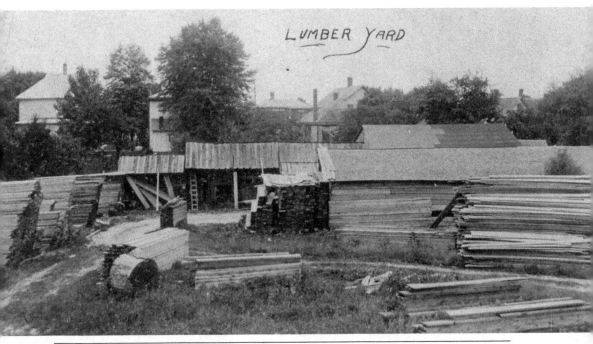

LUMBER YARD

Wilson Cellar came to Westerville from Delaware County when he was about 16 years old. In 1903, Cellar found a job working for a lumber and sawmill, pictured above, owned by D.H. Bard and located just east of the Lincoln Street Cemetery. Bard's death came in 1907, which closed the company. Wilson Cellar decided to form a new lumber company, and in October 1908, the Cellar Lumber Company opened on College Avenue and is still in operation.

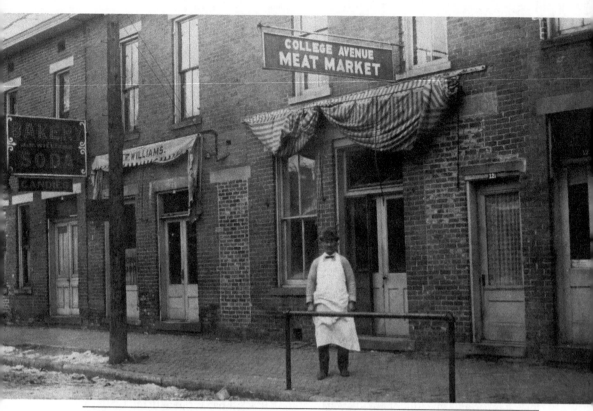

College Avenue, originally Avenue Street, has seen many different businesses come and go. West of the College Avenue Meat Market, John R. Williams opened an ice-cream parlor after multiple friends and family requested homemade ice cream. Established in 1878, Williams developed into a town-favorite; the menu was extended to include lunch and supper, and the name changed to Williams Grill. In 1927, Williams moved to a new location on State Street where Asterisk Supper Club is now located.

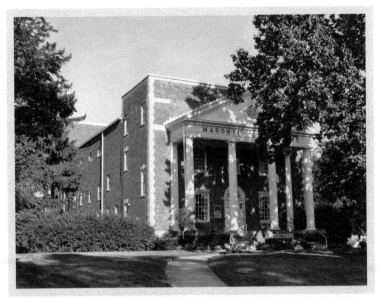

In 1862, the Blendon Masonic Lodge was founded as lodge No. 339. Between 1878 and 1930, regular meetings were held on the third floor of the Robinson Block. On February 22, 1930, the Blendon Masonic Lodge celebrated the dedication of their newly constructed edifice located at 130 South State Street; the structure cost $100,000. The Robinson Block, on the corner of College Avenue and State Street, constructed between 1875 and 1878, is the current home of Good Vibes Winery.

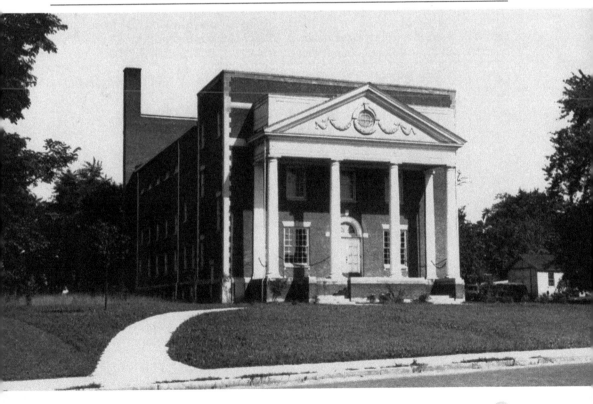

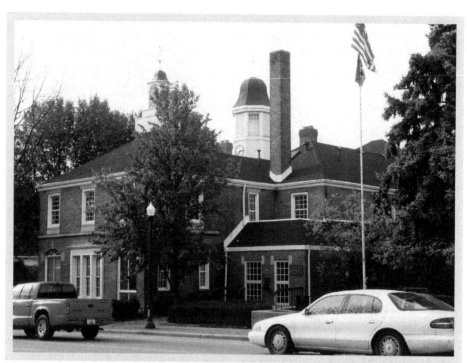

Constructed during the early 1880s, the Sammis-Davis home was heavily modified to serve as the new Town Hall. Westerville purchased the house for $4,300 in 1933. The second floor served as a library and firehouse quarters, and the first floor became offices.

Additions to the rear held a fire station and a jail. The brick for some of the additions came from the original town hall (constructed in 1875 and demolished in 1933), located at 22 East Main Street.

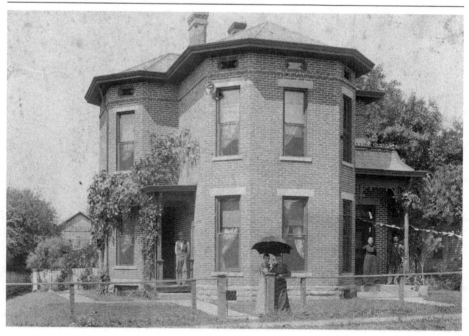

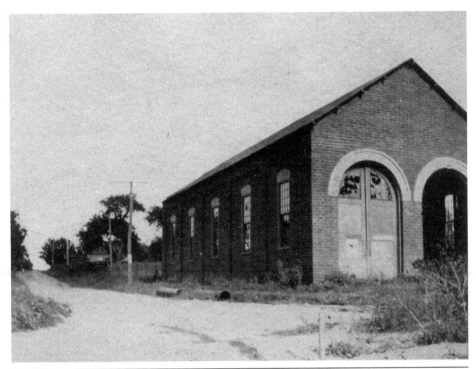

The Columbus and Westerville Interurban Railway Company was formed in 1892 after a crowded train on the Cleveland, Akron & Columbus Railroad failed to stop at the depot; residents were planning to attend the Ohio State Fair but were met with disappointment. Construction for the electric interurban began in 1894 and was in full operation by August 1895. This building served as the car barn for the interurban until the demise of the line came in December 1929.

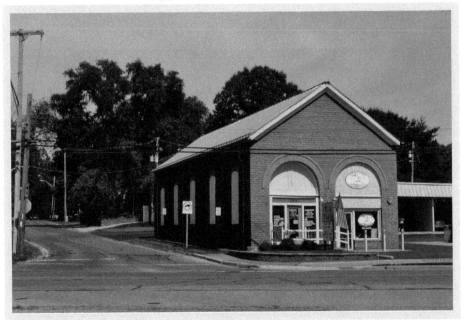

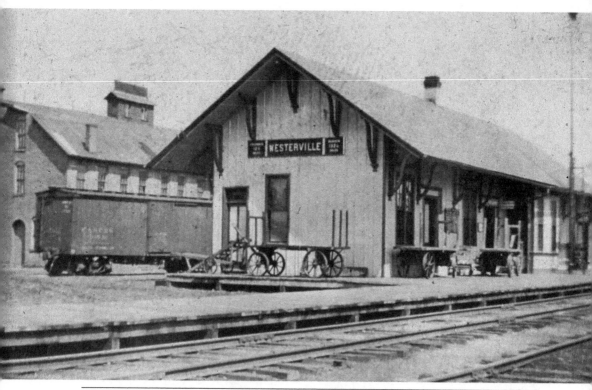

The opening of the Cleveland, Mount Vernon & Delaware Railroad occurred on September 1, 1873. The company, later named the Cleveland, Akron & Columbus Railway, was not originally platted to travel through Westerville. Businessmen from Sunbury, Galena, and Westerville were able to raise $20,000 in stock to persuade the company to shift the route. Townspeople watched with excitement as the track was laid. The depot, seen here, was located at 110 East College Avenue and demolished in the 1980s.

Westerville businessmen, in great anticipation of increased trade, constructed new store buildings on State Street. During the month of September 1873, an observer was quoted as saying, "The town is looking up, and the people—including the faculty—are wondering how Otterbein contrived to do so long without a railroad." With the automobile growing ever stronger, the railroad was completely abandoned in 1982, approximately 109 years after its formation.

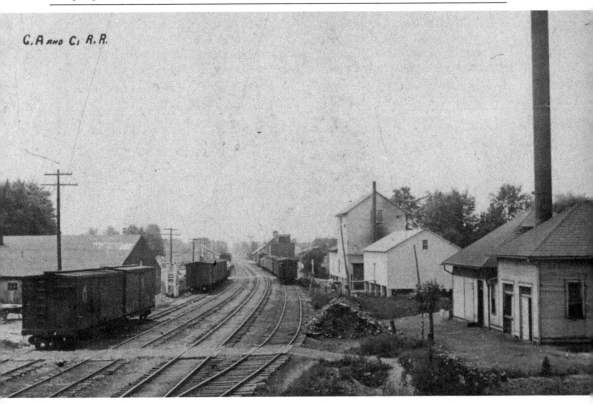

C. A and C. R.R.

In 1924, Ford Motor Company opened a dealership in what is today Hanby Square. Westerville's first car, a single-cylinder Cadillac, was purchased in 1905 and owned by J.A. Weinland. In 1908, complaints of exceeding the 15 mile per hour speed limit through the business district became a community issue. Numerous accidents led to the village council lowering the limit to eight miles per hour. By 1916, the village contained 94 registered vehicles, an automobile for every 30 people.

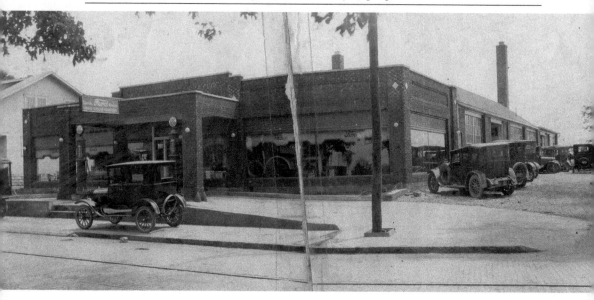

CHAPTER 2

EDUCATION

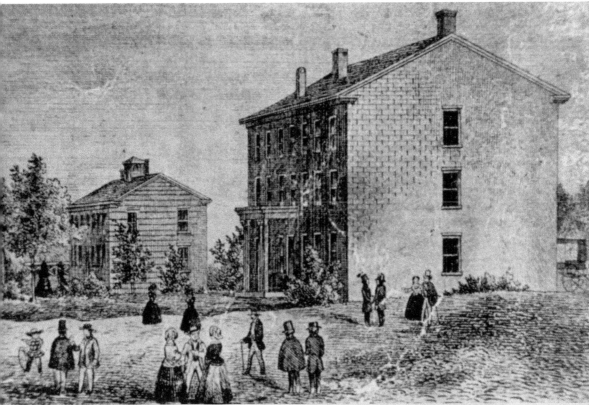

The Blendon Young Men's Seminary is the earliest institution formed in Westerville. Chartered by the Ohio Methodist Conference on February 9, 1839, the school flourished on land given by the Westervelts. Though prosperous for several years, the institution was forced to close in 1844, leaving behind a debt of $1,300. In 1845, Rev. Lewis Davis and Bishop William Hanby proposed the United Brethren Church form an institution of higher learning by purchasing the defunct Seminary land at debt cost.

The purchase included a three-story brick dormitory, and a two-story frame. On April 26, 1847, Otterbein University was formed and named after Phillip Otterbein, who founded the United Brethren Denomination. Pictured here is Main Hall, now the northern grounds of Towers Hall. Main Hall's construction began in 1855. On January 26, 1870, around 2:00 a.m., a raging fire broke out and engulfed the entire building. Since there were no facilities for fighting large fires in Westerville, the building was a total loss.

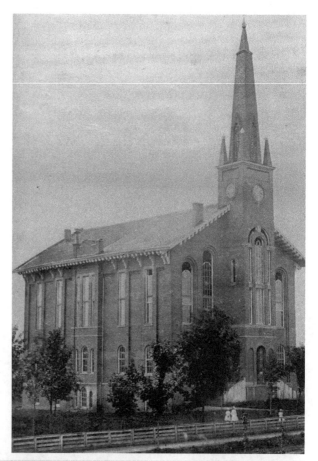

Damage for Main Hall was estimated at $50,000 with insurance covering $20,000. Citizens, faculty, and students took immediate action in response to the fire in fear the college would relocate to Dayton, Ohio; such work included the cleaning of bricks for reuse. Influential members of the United Brethren Denomination were able to prevent its move, and construction of the Administration Building, now Towers Hall, began in October 1870; the new building was dedicated in August 1871.

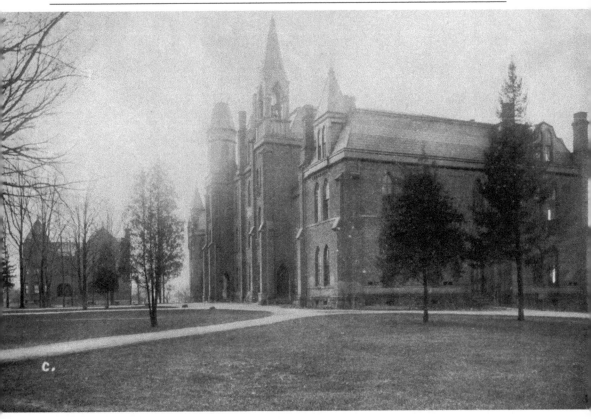

During the 1890s, Otterbein students started a movement to build what would become the Association Building. Students led the fundraising and pledged $6,000 of the needed $15,000, with faculty, alumni, and private donors providing the rest. Ground was broken on June 8, 1892, with several students helping to lay the bricks. The Association Building often referred to as the "Sosh," included parlors, reception and reading rooms, locker rooms, and a gymnasium and was occupied by October 1, 1893.

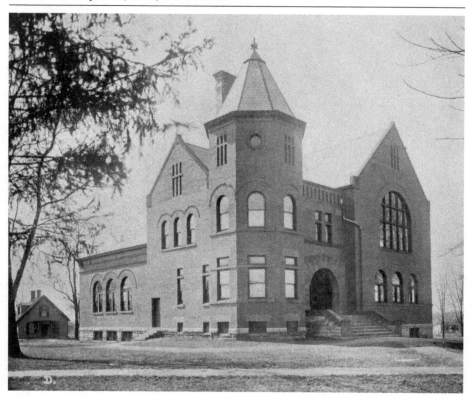

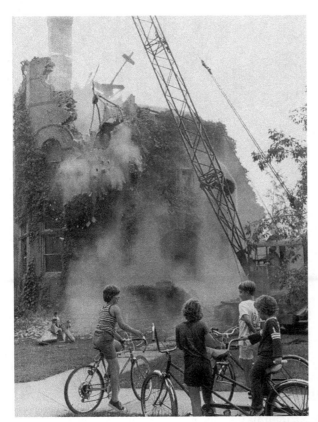

Due to the rise of maintenance costs, Otterbein administration had to make difficult decisions regarding the aging buildings on campus. One of those decisions was to close the Association Building, with its demolition occurring in 1975. Seventeen years later, with the contribution of $2 million from Edwin and Mary Roush, construction of Roush Hall began on the former site of the Association Building. Roush Hall was dedicated in 1994 and houses offices for the president, academic dean, and other departments.

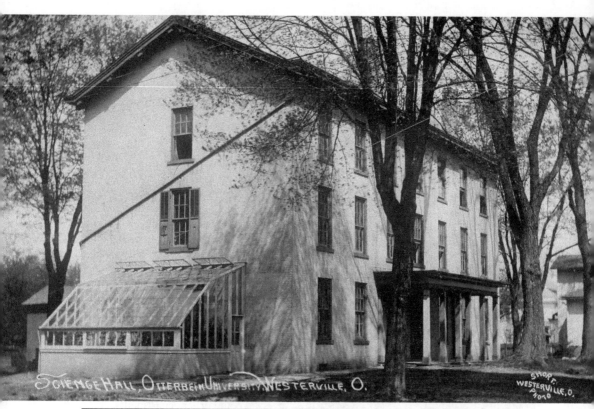

Science Hall, Otterbein University, Westerville, O.

SHORT. WESTERVILLE, O. PHOTO

Named in honor of Jacob Saum for his donation of $1,600, Saum Hall was constructed on the northwest corner of Main and Grove Streets in 1854. Saum was the first new building constructed after Otterbein's founding and originally served as a men's dormitory; the structure was converted into a science hall in 1898. After the construction of McFadden Science Hall in 1919–1920, Saum Hall was converted into a women's dormitory and remained until its demolition in 1970.

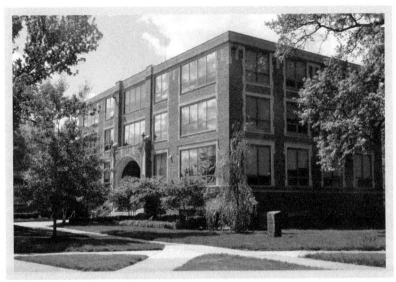

The years leading to World War I had a significant time-sensitive issue that Otterbein needed to address: Saum Hall science building was quickly becoming obsolete. Pres. Walter Clippinger said, "[Otterbein is] losing many students every year because of lack of equipment in science." Perseverance through the war years yielded to the completion of McFadden Science Hall in 1919. Students first used McFadden during the 1920–1921 school year and were excited to use the new state-of-the-art laboratory facilities.

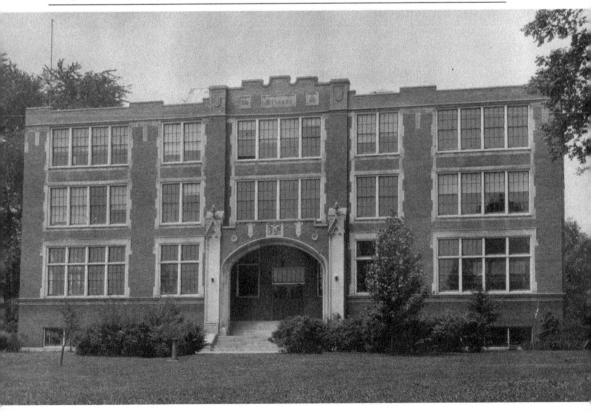

In 1906, George Lambert pledged $25,000 for the construction of a music conservatory. Though progress was delayed with the financial panic of 1907, Lambert Hall was completed in 1909 and stood on the southeast corner of College and Grove Streets. In 1978, the 71-year-old building was closed due to high maintenance and energy costs associated with the country's energy crisis. Music students moved into the renovated Alumni Gymnasium, now known as the Battelle Fine Arts Center.

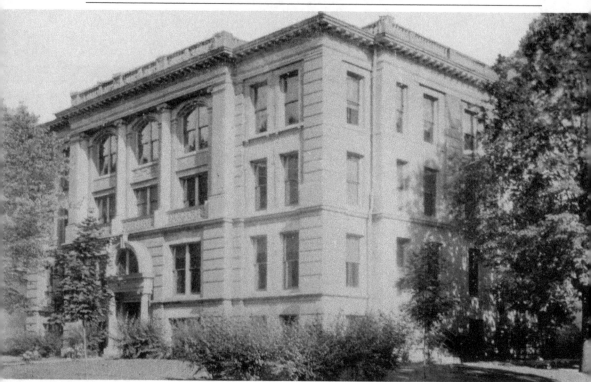

EDUCATION

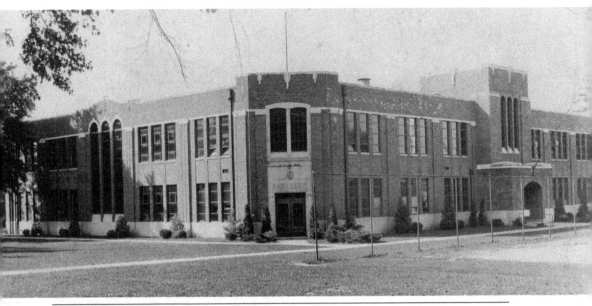

The Alumni Gymnasium, costing $150,000 to build, was completed in 1929. In 1974, with support from a $100,000 challenge grant from the Kresge Foundation, Otterbein was able to construct the Rike Physical Education Center in 1975. The aging Lambert Fine Arts Building was demolished in the 1970s; the land now serves as a parking lot to the north of Cowan Hall. Extensive renovations allowed the old Alumni Gymnasium to be reopened as the Battelle Fine Arts Center in 1978.

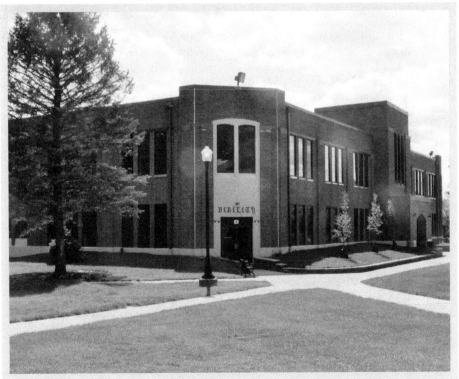

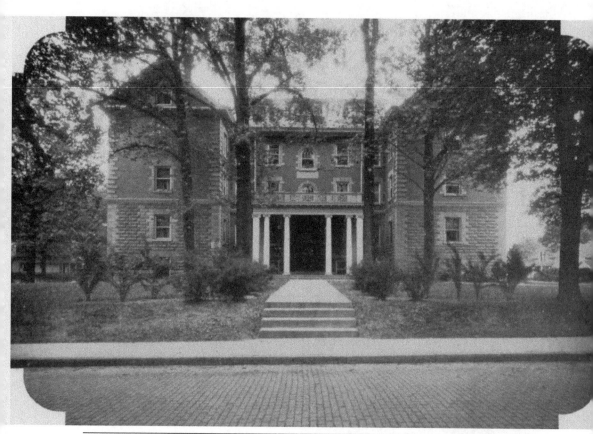

Completed in 1907 and dedicated to the memory of Philip G. Cochran, Cochran Hall was built to serve as a woman's dormitory. Sarah Cochran gave $25,000 for its construction, which was located on the southeast corner of Grove and Home Streets. The building was known for its large and inviting front porch. Tragically, on April 6, 1976, the building caught fire. Otterbein considered rebuilding, but cost was prohibitive, and the ruins were quickly cleared away.

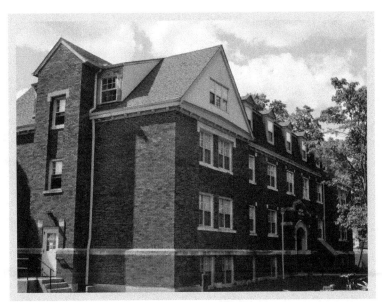

Completed in 1927, King Hall dormitory served the growing male population at Otterbein. Prior to its construction, young men attending school rented rooms in various residences' homes throughout Westerville; women lived in Cochran Hall (1907–1976). Dr. John and Zella King, class of 1894 and 1897, respectively, donated $30,000 for the construction and served as house parents until 1932. In 1988, the building was renovated and renamed Dunlap-King Hall.

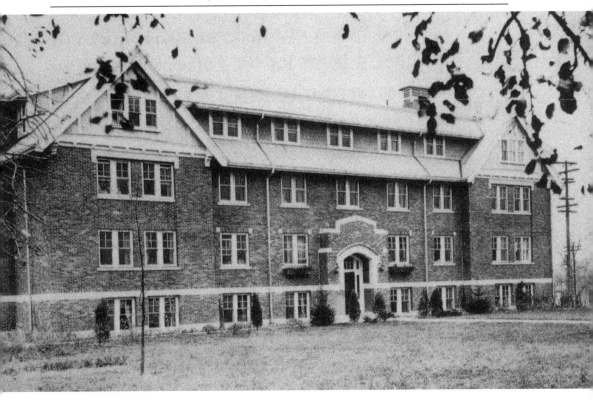

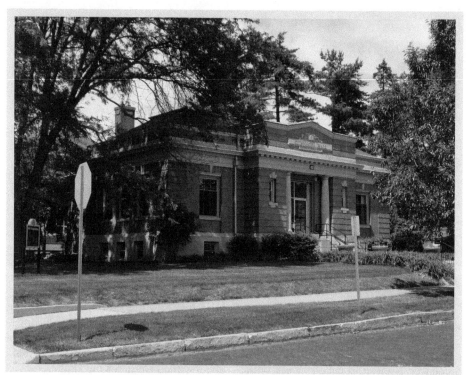

In 1908, the school opened Carnegie Library, which offered students access to approximately 14,000 books. In 1953, to accommodate the growth of the library, Centennial Library, holding approximately 44,178 books, was constructed to the rear of Towers Hall. In 1972, the library moved to its current home and was named Courtright Memorial Library; it holds approximately 300,000 books. Today, Carnegie Library serves as offices of admission and financial aid.

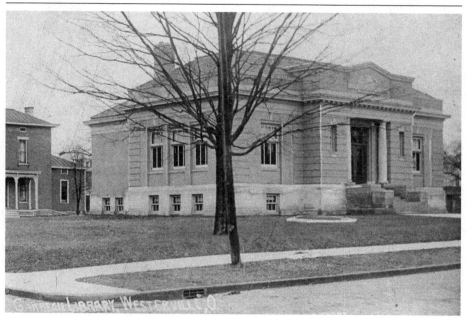

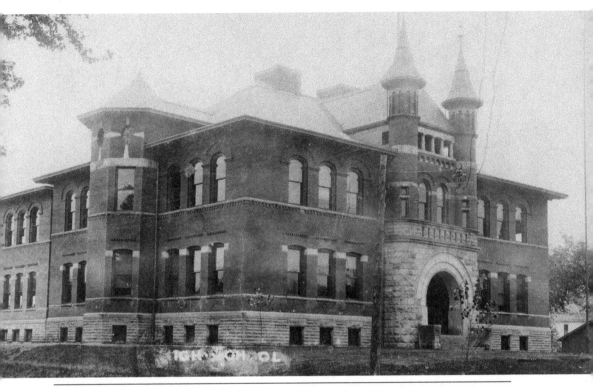

The Westerville School District began in 1855 with the construction of a one-room schoolhouse located on west Home Street. A new one-room schoolhouse, the Union School, was constructed on the east side of Vine Street between Main and Home Streets. Overcrowding became a concern, and citizens voted to demolish the building and construct a new schoolhouse on the same lot, seen above. Designed by Frank Packard, the Vine Street School, now known as Emerson Elementary, opened in 1896 and cost $20,000.

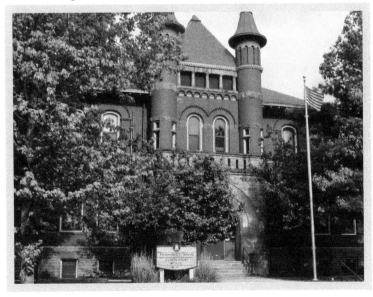

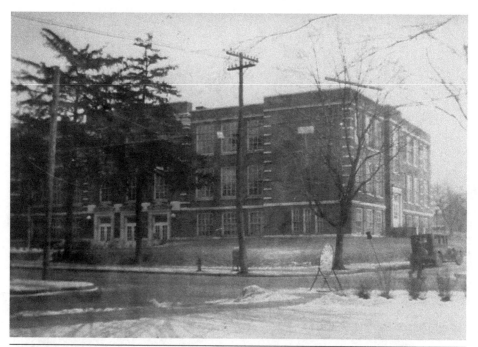

The Vine Street School held all grades, including high school, in one building. In 1921, Westerville residents were shocked to find the North Central Association of Colleges and Secondary Schools revoked Westerville High School's accreditation because of obsolete science and library facilities, as well as the high student-to-teacher ratio. Thus, in 1923, the new junior and senior high school was completed; this returned Westerville schools to an accredited listing. The Vine Street School was also updated and modernized. (Above, from the Westerville History Center collection.)

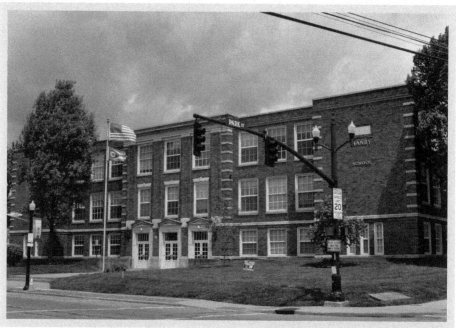

In 1920, the Westerville School District enrolled 607 students. By 1930, enrollment had increased to 997 students. Responding to the growth in the district, voters approved to construct an addition to the rear of the high school structure, as well as to build Longfellow Elementary School on Hiawatha Avenue, completed in 1931. In a joint decision of the Westerville Board of Education and the Cornell family, it was agreed to name all of the elementary schools after poets.

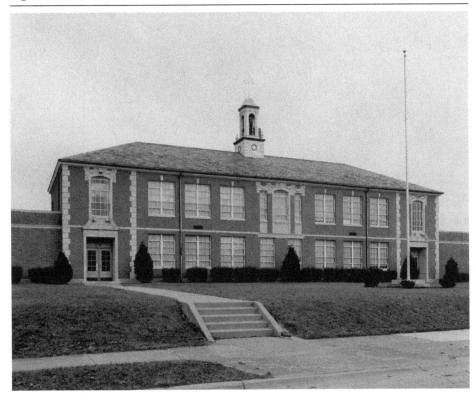

The new high school building, now Westerville South High School, opened on September 12, 1960, a week late. At its opening, the gymnasium, cafeteria, science laboratories, and auditorium were still under construction. Naming the school also created turmoil as the administration voted for "Westerville Lowell High School" after an American poet. The change was greatly protested, and the name was returned to Westerville High School. Westerville now boasts three high schools: South (1960), North (1975), and Central (2003).

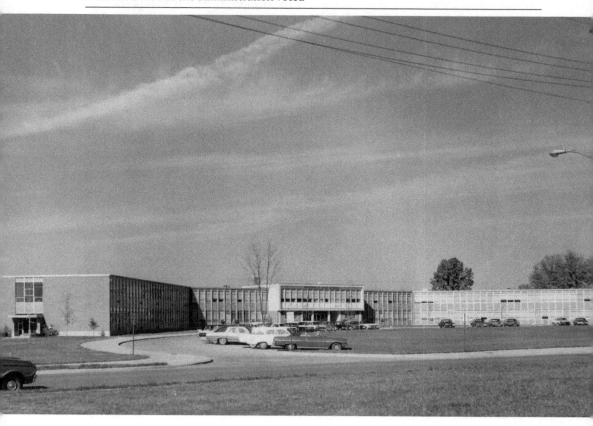

FAITH-KEEPING CITIZENS

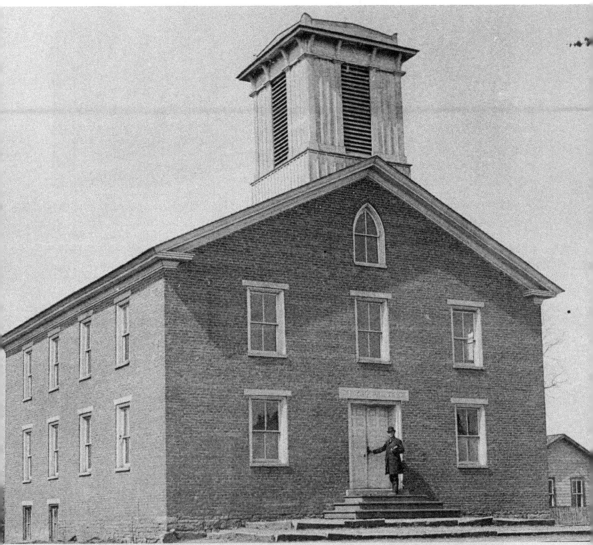

Serving as one of the oldest congregations in Westerville, Church of the Messiah United Methodist finds its roots dating back to 1812. By 1837, the congregation outgrew its log cabin edifice, and in 1838, a new sanctuary was constructed on land given through the generosity of Matthew and Abiah Westervelt. The building, seen here, served the congregation until 1887.

49

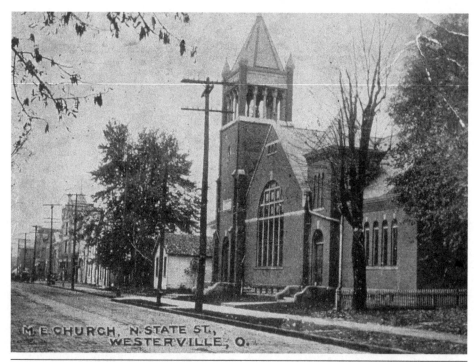

M.E. CHURCH, N.STATE ST., WESTERVILLE, O.

Designed by J.W. Host, the new Methodist Church building was constructed on the same property as the previous building and dedicated Christmas Day 1887. This sanctuary, however, would find itself too small during the 1940s. A building committee called the Forward Movement was organized in 1947, with construction of the current sanctuary beginning in September 1957; Wright and Gilfillen served as the architects. The congregation moved into the new structure in February 1959 under the ministry of Rev. Richard Coad.

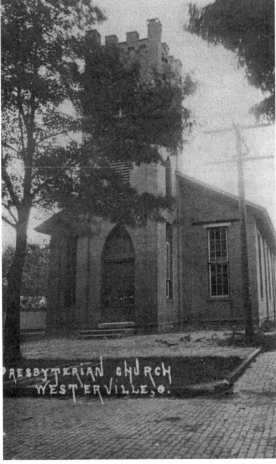

First Presbyterian has a long history with Central College Presbyterian. Beginning as one congregation known as Blendon Presbyterian, the church split in 1843 due in part to the nationwide Old School–New School viewpoints; part of the congregation moved to Central College while the Blendon congregation remained. In 1864, the Blendon congregation reorganized and became First Presbyterian, relocating to their current site. In 1912, the congregation demolished their sanctuary, seen at left, and constructed their current building at a cost of $25,000.

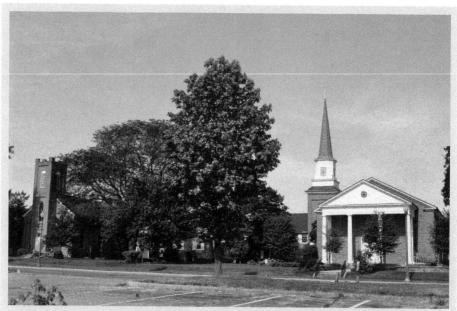

Central College Presbyterian was organized on April 22, 1843, on land given by Timothy Lee and tied to the Central College of Ohio, a Presbyterian college founded in 1842. The congregation used the college buildings for worship until construction of their own sanctuary began in May 1870 and dedicated on Christmas Day of that year. With the growth of the congregation, several additions have been made including the current sanctuary, which was dedicated in June 1966.

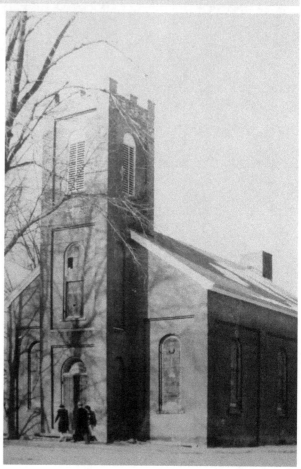

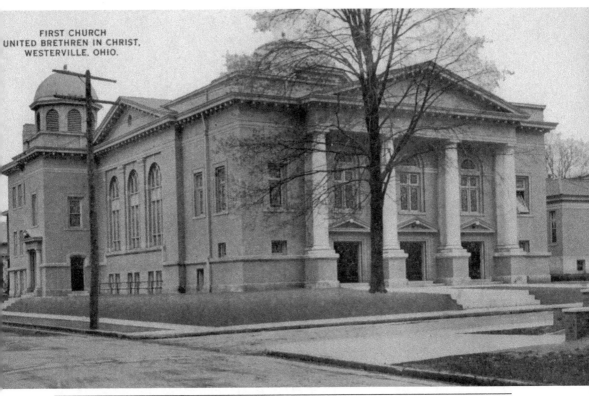

FIRST CHURCH
UNITED BRETHREN IN CHRIST,
WESTERVILLE, OHIO.

The United Brethren in Christ denomination was formed in 1851 with five charter members. The congregation worshiped in Otterbein's chapel until April 30, 1916, when the congregation moved into its current structure. With the merge of the United Church of Christ and Evangelical Church, the name changed to the Evangelical United Brethren Church in 1946. Following the unity of the Evangelical United Brethren and Methodist Episcopal in 1968, the congregation was again renamed and became Church of the Master United Methodist.

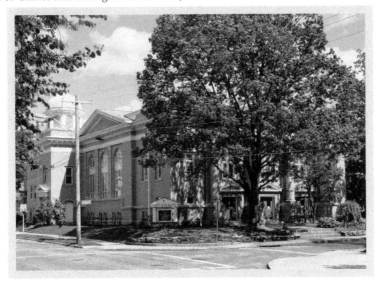

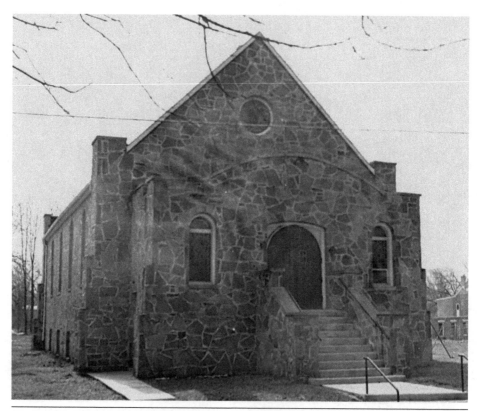

Organized on March 7, 1936, the Church of the Nazarene was founded after a three-week Home Mission Revival Campaign. Reverend Smith was called as the first pastor, and under his leadership the congregation built their first church at 33 East Park Street. In 1968, the congregation took a leap of faith and purchased land on Cherrington Road. Twenty-one years after the land purchase, the church broke ground for their new building, which is still in use. (Above, from the Westerville History Center collection.)

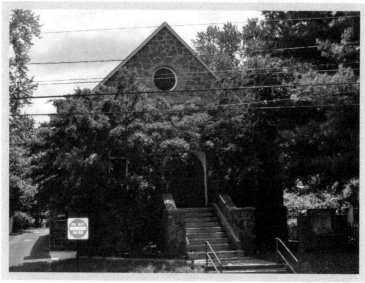

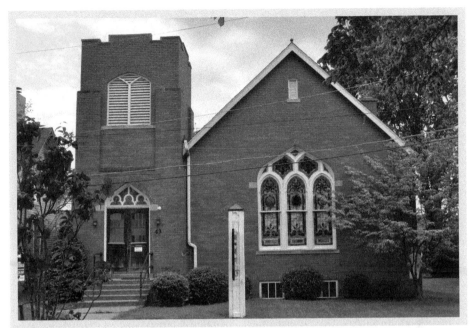

Grace Evangelical Lutheran Church was founded on May 2, 1909, with early services taking place in the town hall. On October 16, 1910, the 50-member congregation dedicated their first building located at 43 East Home Street. In January 1933, St. Paul Lutheran became an independent church and relocated to East Walnut Street; the remaining Grace Lutheran members continued to worship in this sanctuary. On October 10, 1965, Grace Lutheran dedicated its present facilities located at 100 East Schrock Road.

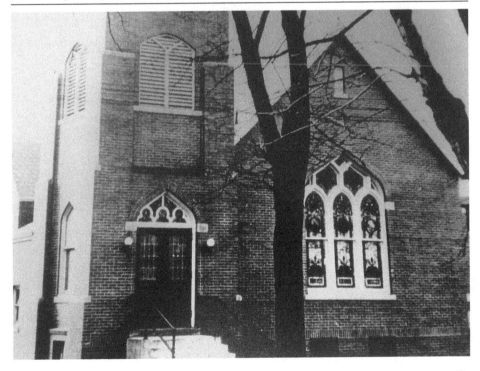

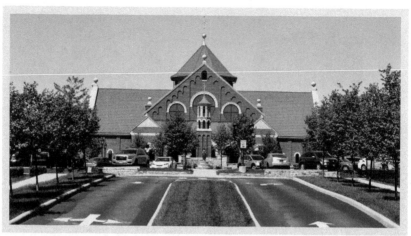

The first Roman Catholic services in Westerville were held in 1913. In 1931, the Capuchin Fathers purchased the Garry Sharp house, their current location, and the home was refitted for a monastery and named St. Paul the Apostle. Shortly after the purchase, the church completed their first sanctuary, which no longer stands. A second sanctuary was constructed in 1969 and replaced with the current structure in 2011. The church now has over 14,000 members. The home of Garry Sharp was demolished in 2001.

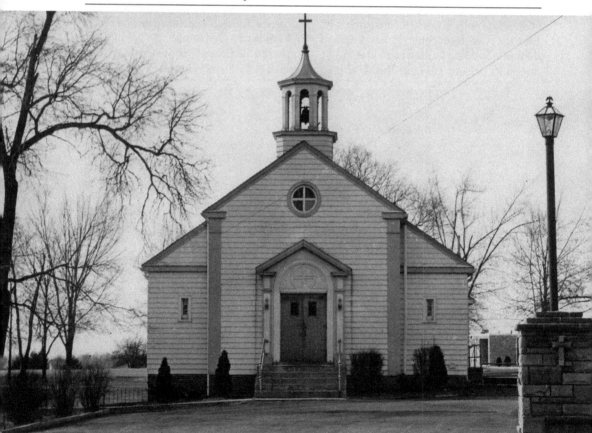

FAITH-KEEPING CITIZENS

CHAPTER 4

VILLAGE OF AMALTHEA

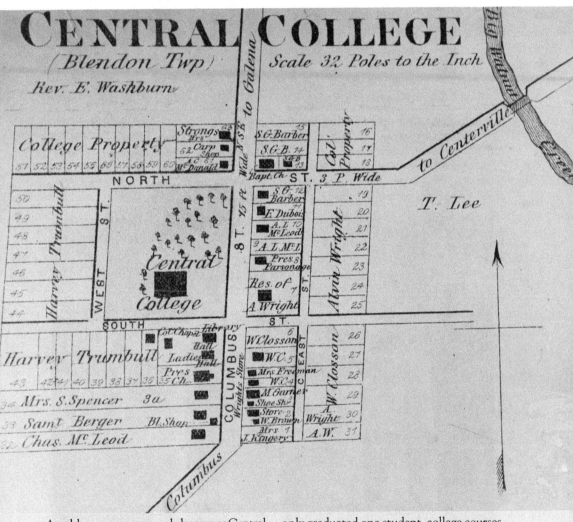

Amalthea, more commonly known as Central College, boasted the Blendon Institute, a college that opened in 1832. The school was reformed in 1842 as the Central College of Ohio, a Presbyterian college. In 1850, having only graduated one student, college courses were discontinued; a preparatory academy continued until 1894. Central College failed to grow and was annexed into Westerville in 1988.

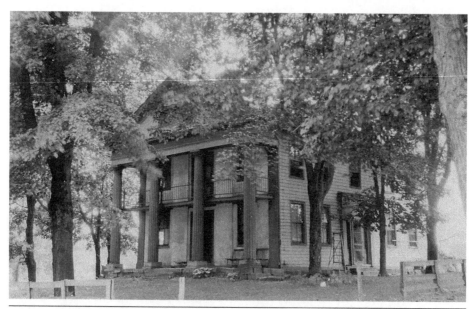

Timothy Lee, founder of Amalthea Village, constructed this mansion during the 1830s on 500 acres purchased in the area of Big Walnut Creek. Lee was engaged to Amalthea Hart in 1805; however, her death occurred two days after the marriage license had been granted. In 1819, Lee married a schoolteacher named Rhoda Taylor. Lee died in 1862 and the home remained in the family for several years until being sold. The home was placed in the National Register of Historic Places in 1947.

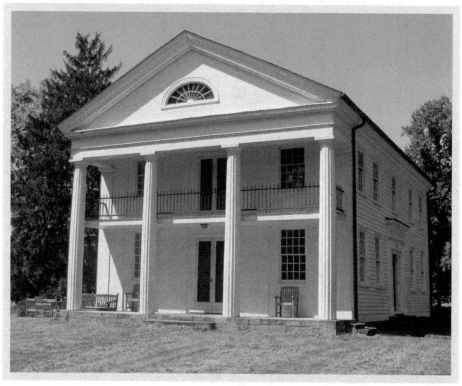

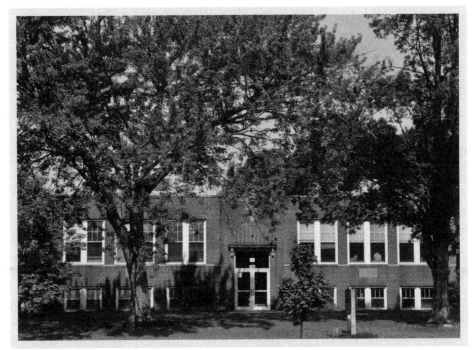

Students in the area of Central College attended the Blendon Township Rural School District. The district, in need of a new schoolhouse in Central College, voted to erect a brick structure in 1904, pictured below. This building served the district until 1937, when it was decided to replace the building with a four-room school, which is still in use today by the Westerville City Schools. In 1955, the Blendon Township Rural Schools became part of the Westerville School District.

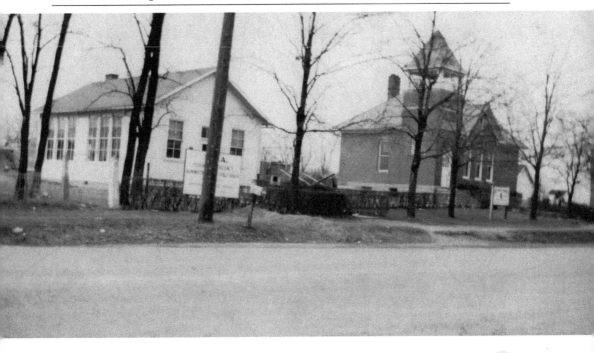

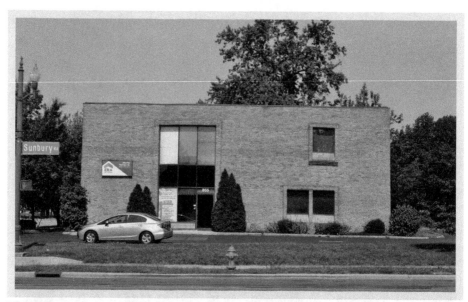

The Hickman Red and White general store was originally located on the northwest corner of Sunbury Road and North Street. The frame structure was built during the first quarter of the 20th century and is pictured here during the 1920s with, from left to right, Tuck Carter and Nettie and Mildred Hickman. On March 22, 1972, the lot was sold, and the building was immediately torn down. A contemporary office building was completed in 1974 and is still in use.

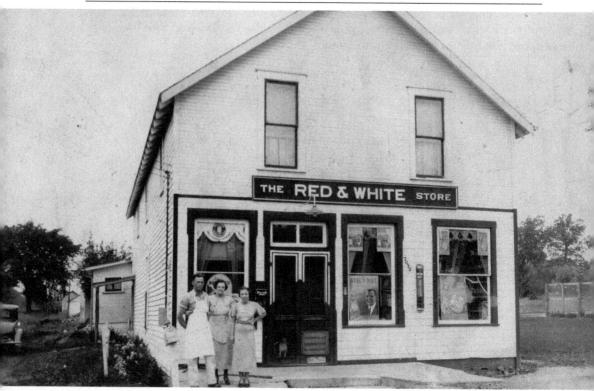

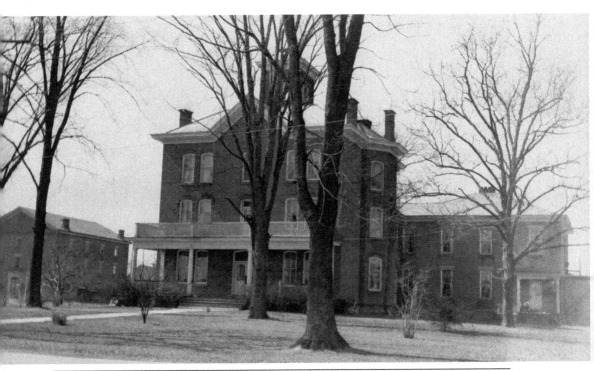

Standing as the last remaining building from the Central College of Ohio, Fairchild Hall was constructed in 1875 and served as the women's dormitory. The school failed in 1894 and the land was put up for sale. Simultaneously, the Ohio School for the Deaf Alumni Association was looking for a tract of land to open a home for the deaf. The association purchased the defunct school property and dedicated the Ohio Home for the Aged and Infirm Deaf in 1896.

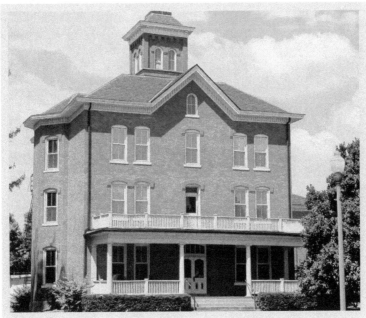

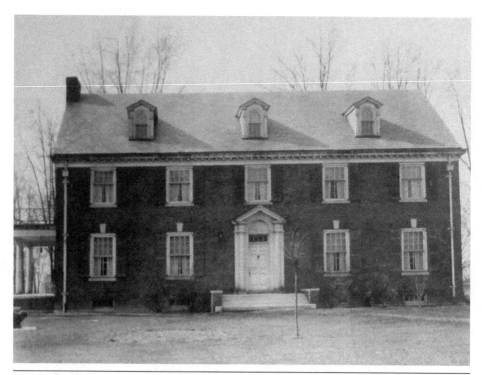

The Ohio Home for the Aged and Infirm Deaf, the first home of its kind in the Midwest, thrived for many years. It was quickly decided that a men's dormitory was needed, and on February 25, 1922, Wornstaff Hall was completed. Fairchild Hall held rooms for ladies, and married couples as well as parlors and dining rooms. Today, Wornstaff is owned and used by the Central College Presbyterian Church for offices. Fairchild is also owned by the church.

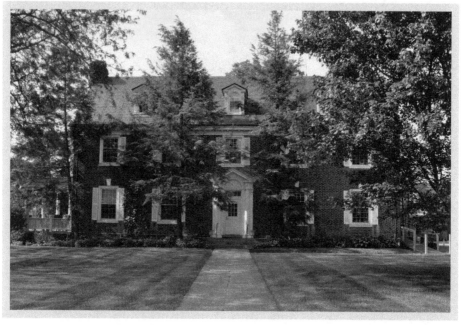

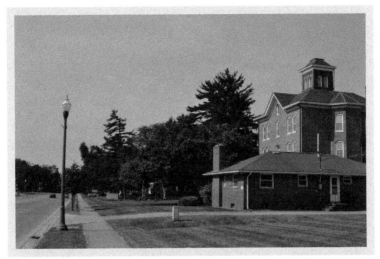

The Ohio Home for the Deaf was completely self-sufficient. With a fully operational farm, the residents, who took great pride in their effort, helped with the work as crops were sold to generate money for the home. Ohio banned labor in retirement homes, which forced the farm to close during the 1950s. With the aging buildings and no income from the farm, the home decided to move to a new property to the south and was renamed Columbus Colony in 1977.

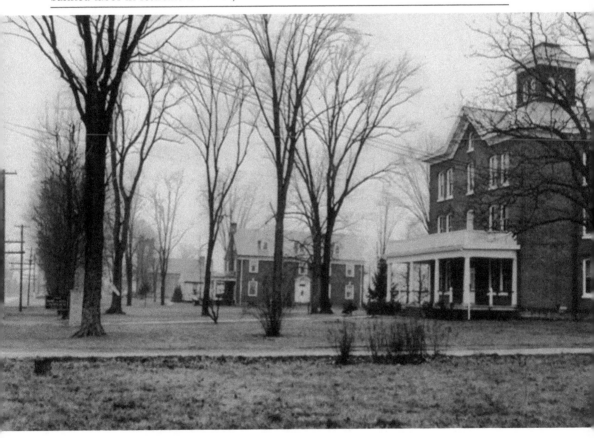

May 30, 1931, was an unforgettable day for many living in Central College. During the afternoon hours, a tornado swept through the area pinpointed at the intersections of Sunbury and Central College Roads. The high winds leveled Clapham's Automobile Serving Garage and ripped the roof off of the Baptist Church (used by the Blendon Township Rural School District during that time). Curious individuals came from all around to see the damage and offer assistance.

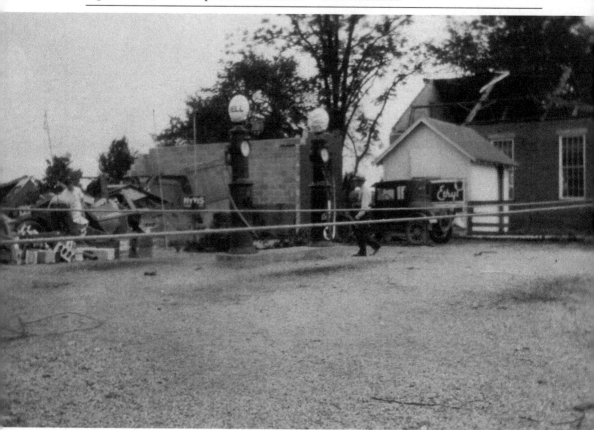

CHAPTER 5

WESTERVILLE WHISKEY WARS AND THE "DRY CAPITAL OF THE WORLD"

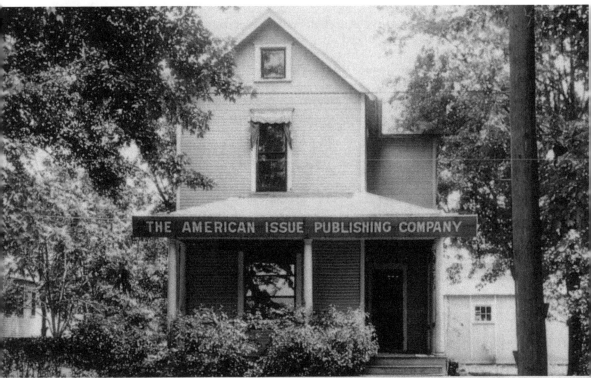

In 1908, Westerville heard rumors that the Anti-Saloon League of America wished to relocate their headquarters. Westerville Board of Trade raised $7,000 to purchase a home and land (where the Westerville Public Library currently sits) and sent the postmaster to Washington, DC, to present the advantages of Westerville. The headquarters accepted the offer and moved to Westerville in 1909.

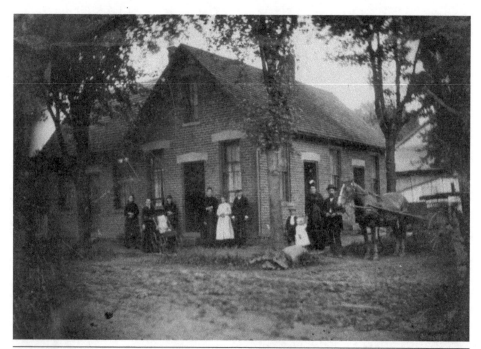

Prior to the arrival of the Anti-Saloon League, the village experienced what was to become known as the Whiskey Wars. Westerville's fifth ordinance was passed in 1859, which forbade the sale of alcohol. Henry and Phyloxena Corbin opened a three-room saloon on July 1, 1875. Citizens expressed their disapproval by summoning a crowd around his business on the corner of Knox and Main Streets. Protestors peacefully prayed, sang hymns, and gave speeches. This, however, did not discourage Henry.

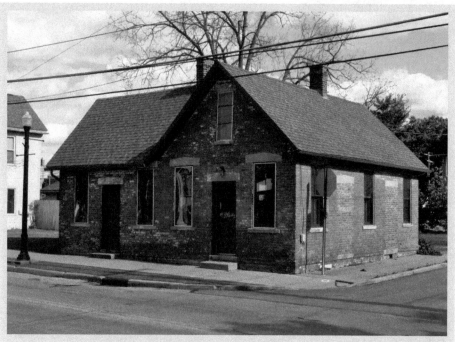

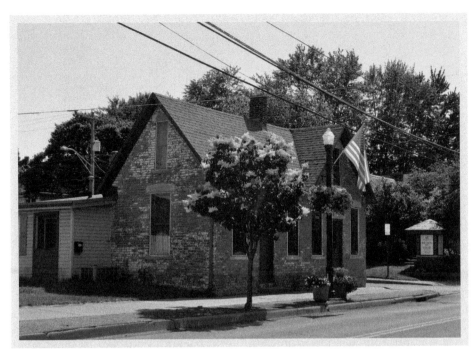

Peaceful protests did not change Henry Corbin's idea of a saloon in Westerville. Citizens took matters into their own hands with more belligerent tactics, including the draining of liquor kegs, breaking of windows, and the use of rotten eggs. Following a temperance meeting one evening, an explosion occurred at the saloon. The building had been dynamited, which blew off the roof and destroyed the bar rooms. A trial was held with no persons found guilty, and Corbin decided not to reopen.

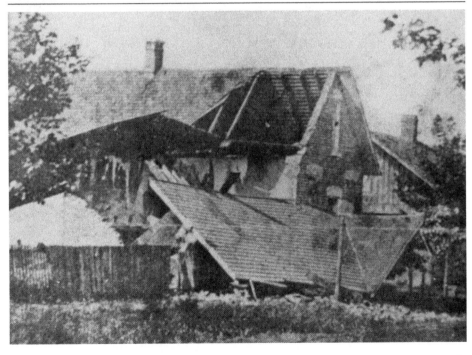

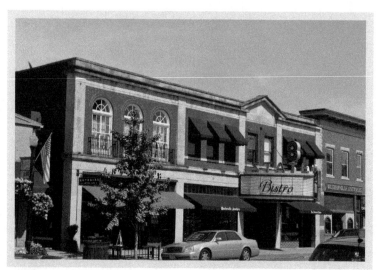

In 1879, Henry Corbin returned to Westerville, purchased the Clymer House Hotel, and once again tried to open a saloon. The saloon, kept in the basement of the hotel, was met with protestors in an effort to shut Corbin down. On September 15, 1879, another large explosion occurred and completely destroyed the frame structure. To this day, no evidence as to who committed the act has ever been found. Many American newspapers published articles about this event.

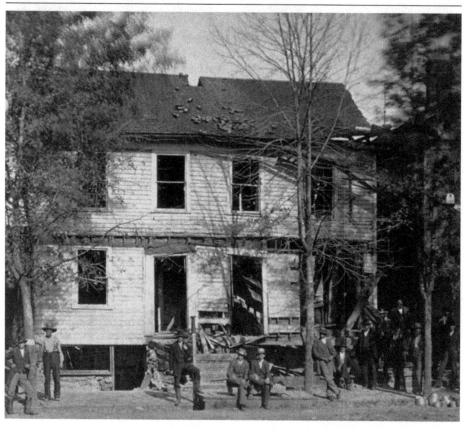

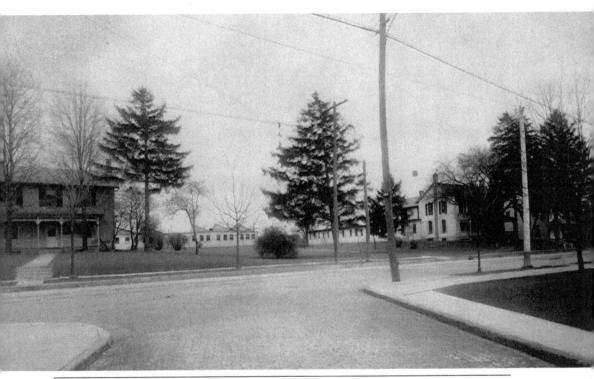

Excitement raced through Westerville upon the arrival of the Anti-Saloon League of America on February 12, 1909. On land once belonging to George Stoner, the League built a printing plant responsible for all of the paper material and books published by the League; at the time, the American Issue newspaper had a circulation of over a half-million readers. In 1910, the League produced an estimated 200,000 pages. By 1919, the estimated amount grew to 837,000 pages.

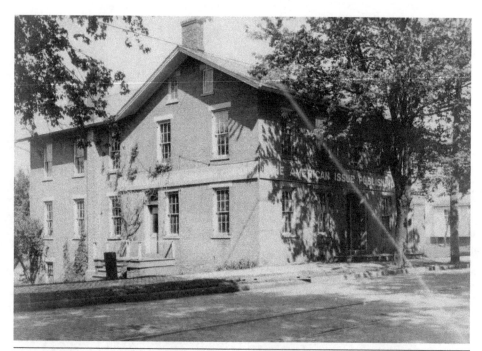

Constructed around 1852 by George Stoner, this structure was built atop a natural underground stream thought to have healing powers. Also serving as a stagecoach stop and inn, Stoner was said to have the fastest hack service between Columbus and Westerville. George Stoner died in 1884 at 89 years old. In 1909, this building became home for the publishing offices of the American Issue and was used as such until 1936.

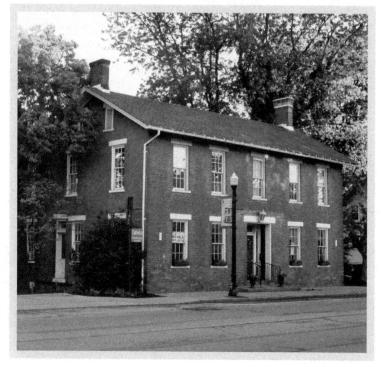

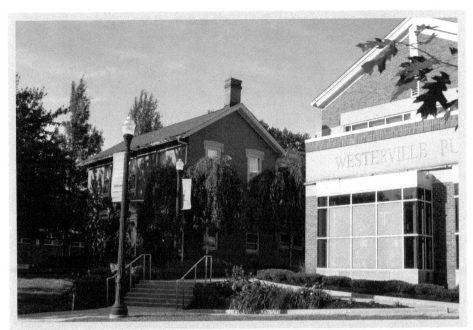

Built during the 1850s by George Stoner, this home served as the National Headquarters for the Anti-Saloon League. In 1920, the league witnessed its biggest accomplishment with the passing of the 18th Amendment to the Constitution; much of the league's material caused the nationwide ban of alcohol. With the ratification of the 21st Amendment in 1933, the league mourned and would begin to face their collapsing mission. (Below, from the Westerville History Center collection.)

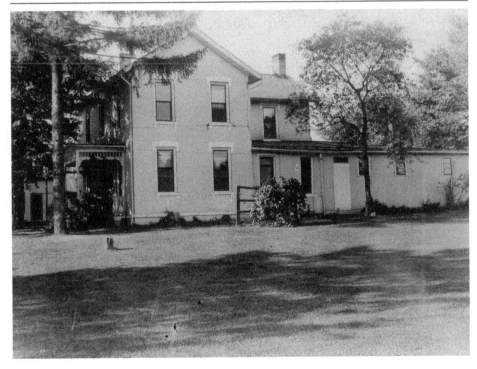

The Anti-Saloon League changed its name to the National Temperance Education Foundation in 1948. During the 1940s, a larger library was necessary for the growing town, and the American Issue was the first to offer assistance by donating a portion of their land. Westerville Memorial Library, located in its current home, was dedicated March 13, 1955. By 1978, the library owned the league headquarters, now the Anti-Saloon League Museum, as well as the printing facilities, which no longer stand.

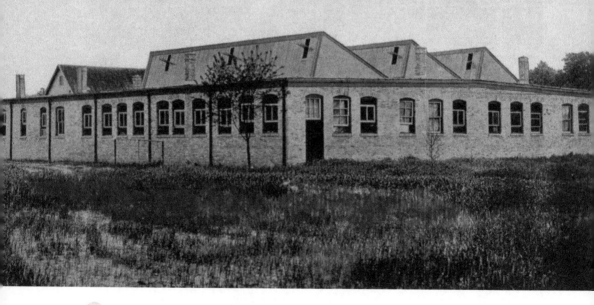

AMERICAN ISSUE PUBLISHING CO.
WESTERVILLE. OHIO.

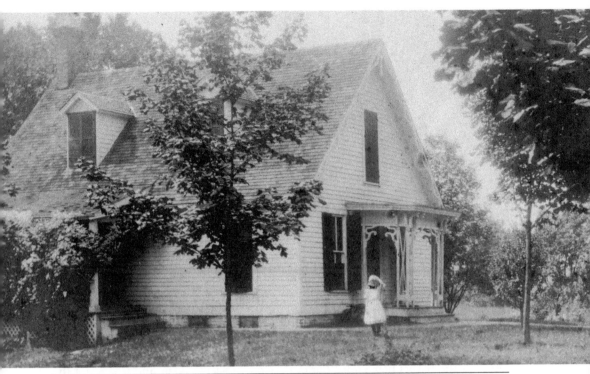

Originally situated on the southwest corner of Grove and Park, this home was built as a farmhouse around 1855 by Abraham Winter. In 1909, Purley Baker, superintendent of the Anti-Saloon League, purchased this home along with 11.5 acres. The structure was moved approximately 210 feet west (145 West Park Street) in 1911, massively renovated, named Dale Cottage Place, and served as the caretaker's cottage for the Bakers. Purley and his wife, Lillie, built their home and named it Greendale in 1910.

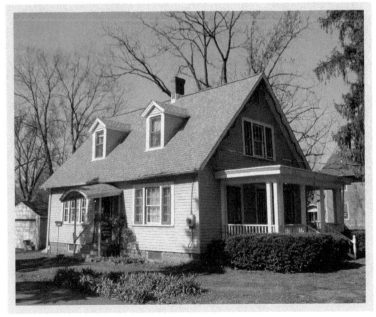

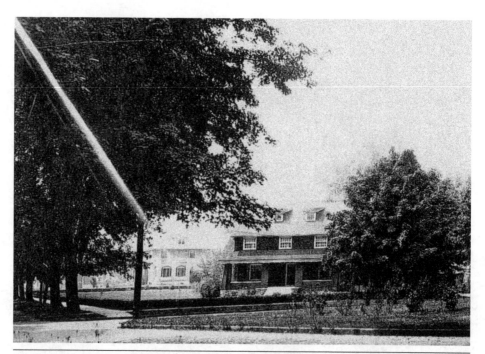

Greendale, located at 131 West Park Street, served as the Bakers home until Purley's death in 1924. In 1930, the league offered the lower floors to Westerville for a library until the land was sold in 1935; this marks the beginning of the Westerville Public Library. Otterbein purchased the property in 1947 for a president's home and renamed it the Howard House in honor of college president J. Gordon Howard. The house now holds offices for the university.

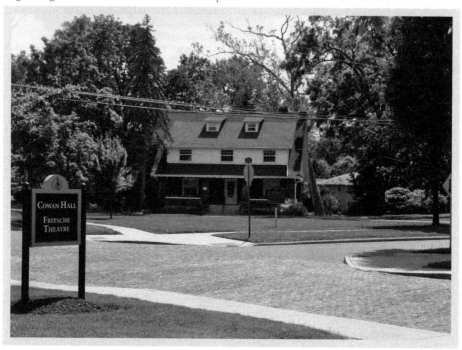

WESTERVILLE WHISKEY WARS AND THE "DRY CAPITAL OF THE WORLD"

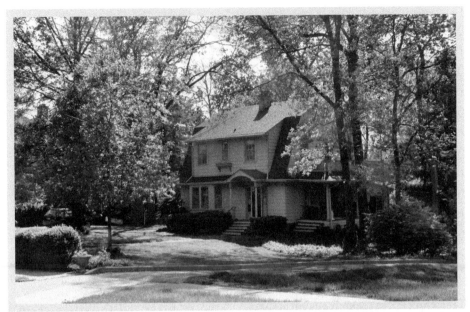

Located at 67 South Grove Street, this home was built by the Bakers in 1923 and became the home of Lillie Baker after the death of her husband. Lillie lived here until her death in 1929. Full effects of the 21st Amendment were felt by 1934, and the American Issue began selling the Temperance Row houses. This home was sold in September 1934, and by the end of 1935, all of the homes had been sold off.

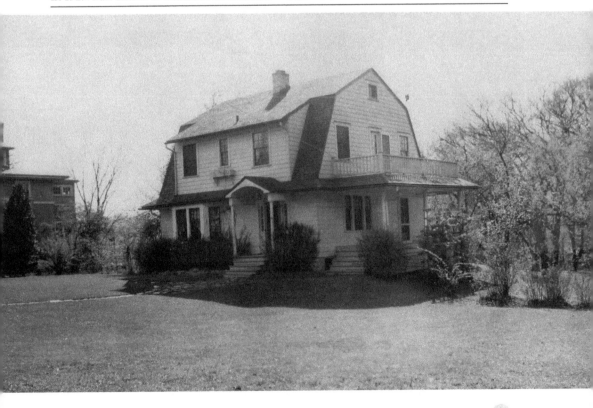

Temperance Row, seen here, got its start when Purley Baker purchased 11.5 acres and divided the tract into lots; lots were sold to league leaders for their homes. With their nationwide anti-alcohol efforts, Westerville became known as "the Dry Capital of the World." By 1931, Dr. Howard Hyde Russell, founder of the Anti-Saloon League of America, reported that six million "young folk" were registered and enrolled as abstainers.

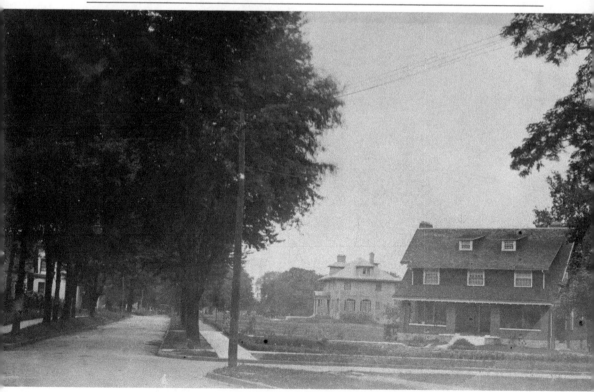

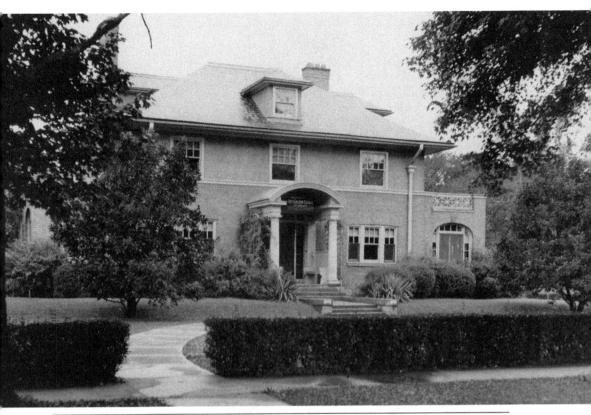

Located at 79 South Grove Street, this house became home for Dr. Howard Russell and his family. Russell sold the home to Ernest Cherrington in 1915. Cherrington moved to Westerville from Chicago in 1909 and served as editor-in-chief, publisher, and general manager of the American Issue Publishing Company. The home was sold in 1925 to the league for office use and today serves as the "Country Club" (Phi Kappa Phi) fraternity house.

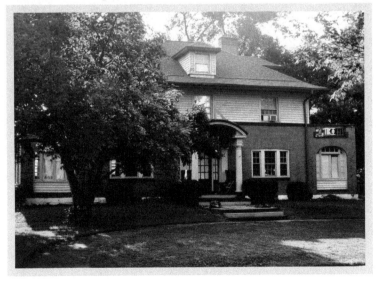

149 West Park Street was constructed around 1914 and occupied by Boyd Doty and family; Doty served as legal consultant for the American Issue Publishing Company. The home fell into disrepair and was demolished by Otterbein University upon purchase of the property in 2004. To the west is 159 West Park Street. Completed in 1915, this house became home for Reverend Edward Moore and family. In 1948, the home was purchased by the Eta Phi Mu Alumni Association and serves as the "Jonda" (Eta Phi Mu) fraternity house.

RESIDENTS, ROADWAYS, AND FARMING

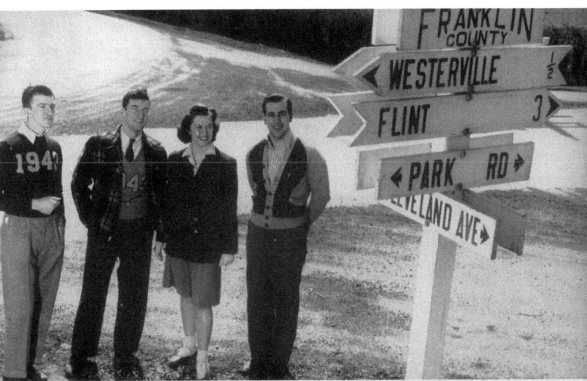

In 1909, a pamphlet was published marking Westerville a "beautiful clean village with its shady avenues, paved streets, electric lights, sanitary sewers, water works, natural gas, telephone systems, steam and electric railroads, useful industries, cultured homes, pure water, healthful atmosphere, and a happy prosperous people." Citizens were proud of their village and thrived on their high upright moral standings.

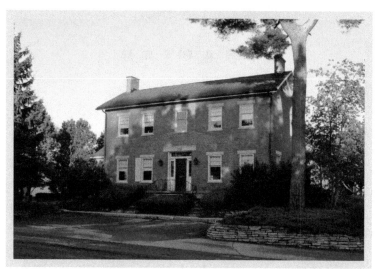

Garrit Sharp and his wife, Anna, came to the area from New York in 1810 and settled on approximately 450 acres situated on the Franklin and Delaware County line. Starting with a modest log cabin, Garrit built this home in 1849 and laid the foundation in line with the North Star. The village was originally named Sharp's Settlement until later being renamed after the Westervelt family. Today, the house is known as the Alkire House and serves as office space.

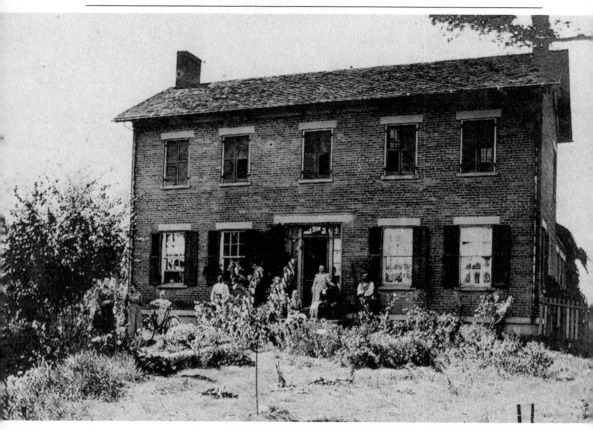

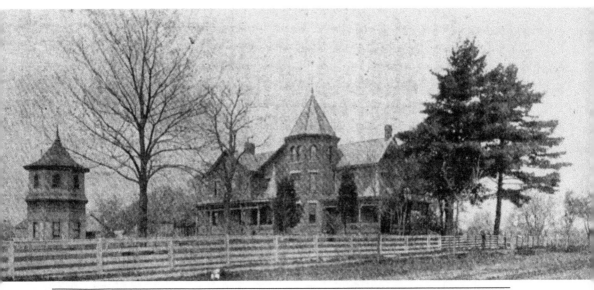

Garry Sharp, one of 13 or 14 children (accounts differ) born to Garrit and Anna Goodspeed Sharp, built the original portion of this home around 1857 that was formally located on land now owned by St. Paul's Catholic Church. Garry married Nancy Dixon in 1836 and had no children. The home was likely used as a station on the Underground Railroad, as the Sharps were known for their strong abolitionist ideals.

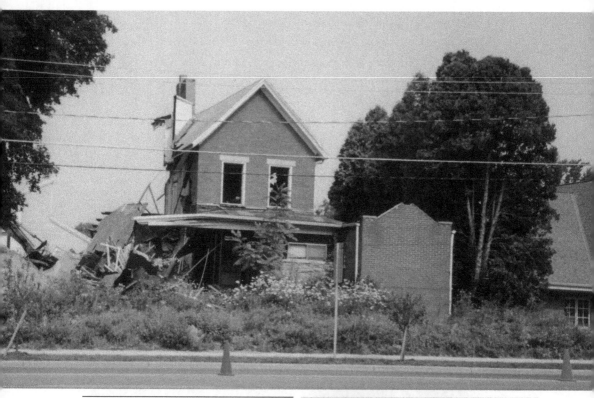

Garry Sharp died in 1879, and Nancy continued to live in the home until 1890 when she sold it to Garry and Alta Meeker. Garry Sharp was well known and remembered for his Christian virtues. In 1907, Alta Meeker sold the home and land to a private family. In 1931, the Capuchin Fathers purchased the home and modified it to serve as a rectory for St. Paul Roman Catholic Church. The home was demolished by the Church in 2001.

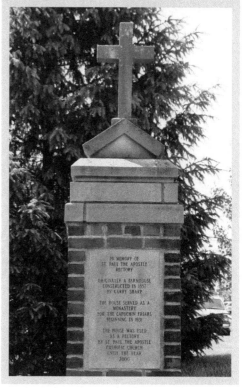

RESIDENTS, ROADWAYS, AND FARMING

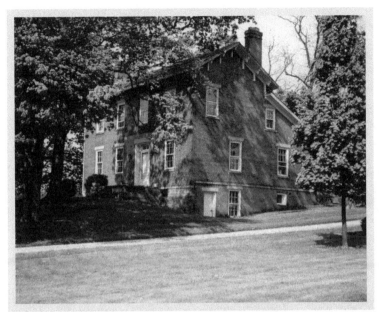

Possibly used on the Underground Railroad, 656 Africa Road was built in 1857 by Stephen Sharp, eldest son of Garrit and Anna. Having lost the use of one hand, Stephen had the home fitted with specially crafted door latches. With the assistance of his sons, 117 acres were cleared for farming. Stephen resided here until his death in 1886. Since 1916, the home and 57 acres have been owned by the Rushmer/Holmes/Bean family.

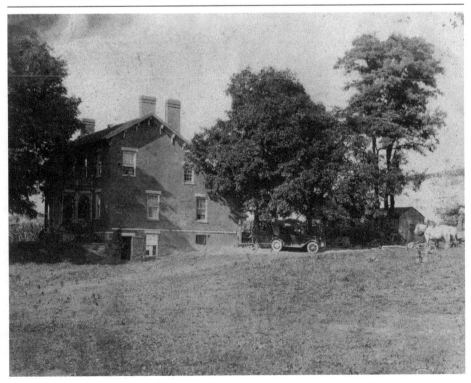

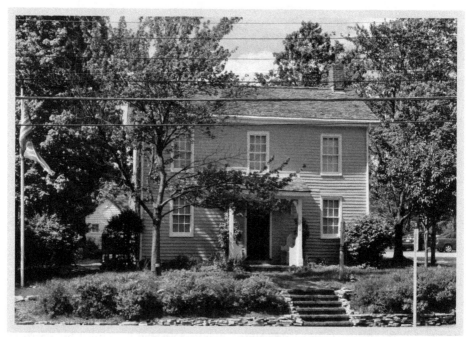

In 1853, Bishop William Hanby and family moved into this home originally located near the corner of Main and Grove Streets. The Hanbys were avid abolitionists. William and Ann's eldest son, Benjamin, composed his most famous song, "Darling Nelly Gray," while living in this house. Based on a true incident from his childhood, the song tells the tragedy of a runaway slave whose sweetheart had been separated from him and sold to another owner. Today, the Hanby House is owned by the Ohio History Center and serves as a memorial to the Hanby family.

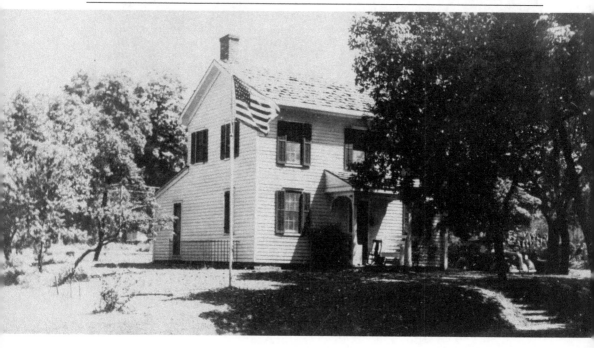

RESIDENTS, ROADWAYS, AND FARMING

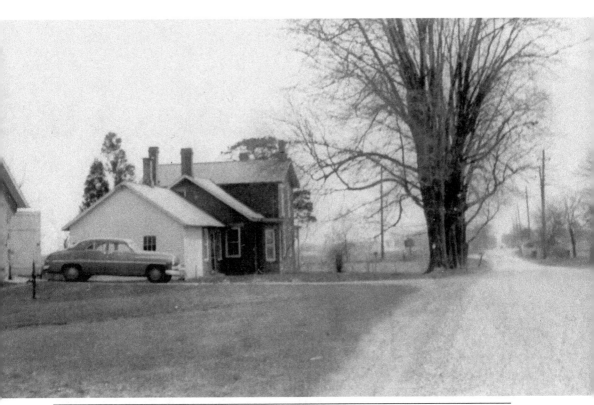

Cleveland Avenue, seen here looking south from the Everal homestead, was originally called Harbor Road. The name "Harbor" is said to have come from an area near 161, which was once an area of dense woods with a narrow dirt path. Horse thieves were often hiding, or "harbored," in the woods and created very dangerous conditions for travelers. These horse thieves stretched a tristate area through Pennsylvania, Ohio, and Indiana. (Above, from the Westerville History Center collection.)

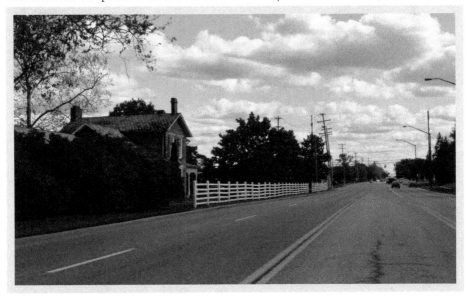

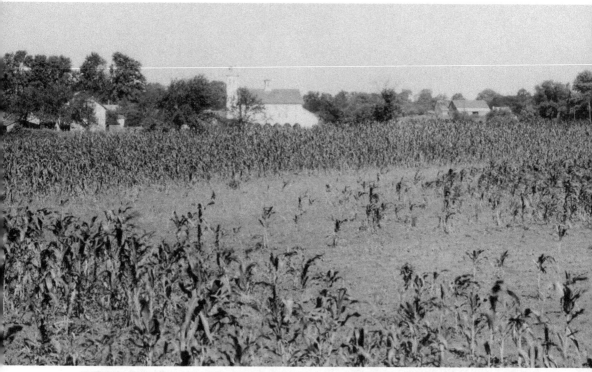

John Everal, a notable Westerville citizen, founded the J.W. Everal Tile Company in 1872 using clay deposits natural to the banks of Alum Creek. The Everal homestead was built in the 1870s; the barn was constructed in the 1880s. In 1876, the company began producing brick, much of which was used to construct buildings around town. Operating nine months of the year, the company produced 25,000 bricks a day at its peak.

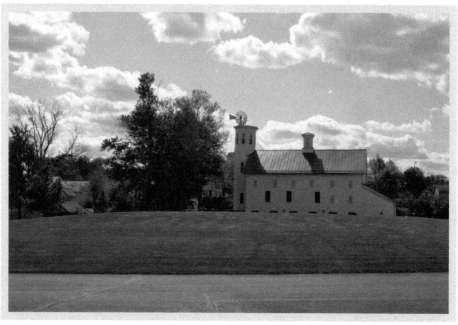

RESIDENTS, ROADWAYS, AND FARMING

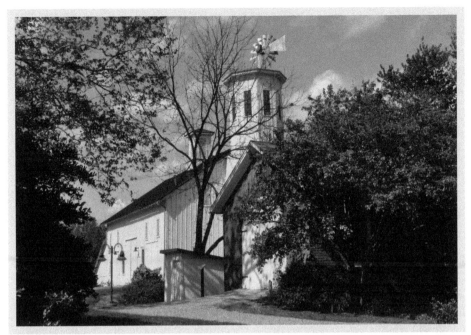

The Everal farm was named Rosedale after John Everal's beautiful rose gardens. Depleting resources caused the Brick and Tile Company to close in 1912. The barn was placed in the National Register of Historic Places in 1975, and the farm was donated to Westerville in 1978. On March 23, 1999, the barn was moved 40 feet to the east to accommodate the widening of Cleveland Avenue from two to five lanes. Today, the barn serves as a reception venue for Westerville Parks and Recreation. (Below, from the Westerville History Center collection.)

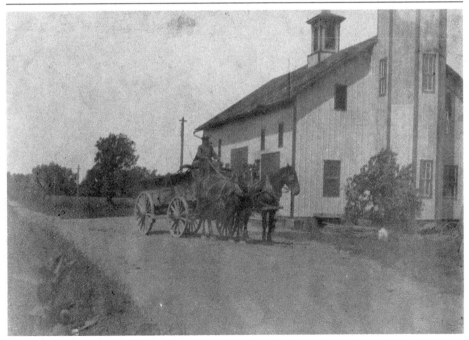

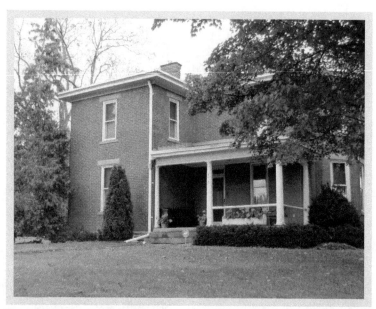

In 1883, Thomas Holmes and his aunt Mary purchased a home on 27.5 acres north of Westerville. A barn was constructed immediately, and by December 1884 this home was completed. The original house was removed shortly after. Thomas held many titles including supervisor on the State Road, entrepreneur, owner and farmer of over 170 acres, a director of the bank, a member of the Presbyterian Church, and a faithful family man. The house remains in the Holmes-Bean family.

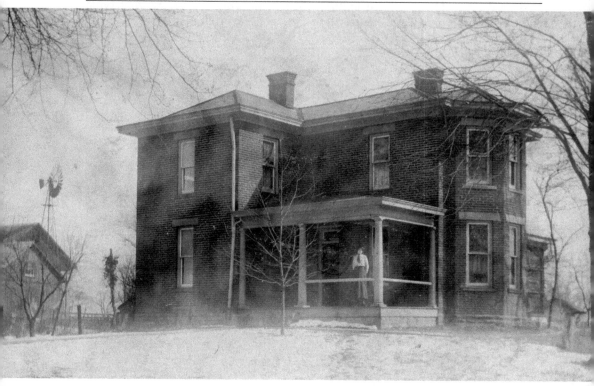

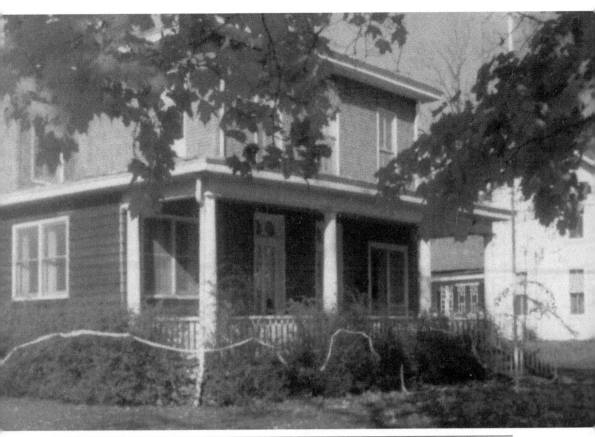

George and Lucinda Brewer constructed 25 South Vine Street around 1873. On June 4, 1877, the Brewers sold a portion of their land to Samuel Rigal for the formation of the Westerville Church of the Evangelical Association, now the Frank Museum of Art at 39 South Vine Street. On October 3, the Brewer family sold the home to the First Presbyterian Church for use as a parsonage, which continued until 1943. The home remains a private residence.

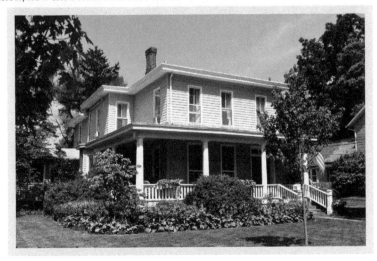

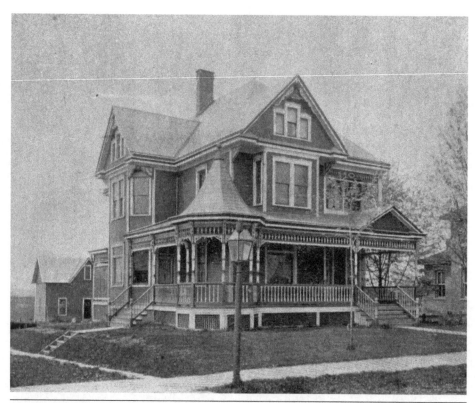

John and Rebecca Knox lived in this home located at 161 North State Street during the late 1800s. On December 17, 1873, William Sharp gave six acres of land to the village, which became known as Sharp's First Addition. The large Victorian home, pictured here, was constructed on lot 5 during the fourth quarter of the 19th century. John and Rebecca later moved to West College Avenue. John died in 1902, and Rebecca died in 1923.

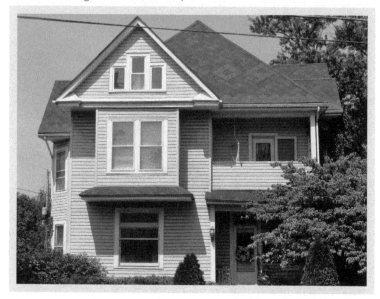

Once located at 138 West Main Street, this home stood where the Otterbein Courtright Memorial Library now stands. Likely constructed during the 1870s, this home was owned by Reverend Henry A. Thompson and his family. Reverend Thompson served as Otterbein's president from 1872 to 1886. The house was later owned by the Cook family, represented in the photograph below. Otterbein purchased the home in 1963, removed the Second Empire architectural detailing, and demolished it in 1969.

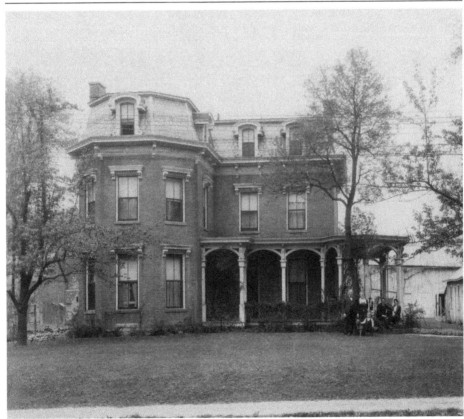

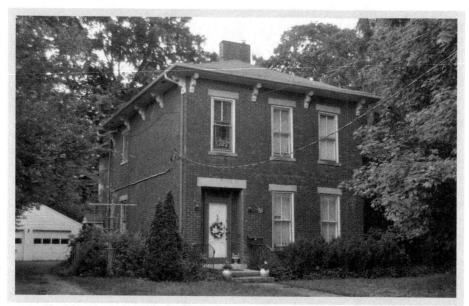

Situated at 56 West Home Street, this home belonged to Vernon and Mary Lee during the early 20th century. Mary became Westerville's postmistress during the 1920s and had a large concern for politics. Her interest allowed for the formation of friendships, which brought Sen. Frank Willis, Gov. Myers Cooper, Vice Pres. Calvin Coolidge, and Pres. Warren G. Harding to Westerville. Failing health forced Mary to move to Springfield, Ohio; her dying wish was to visit Harding's home one last time in Marion, Ohio.

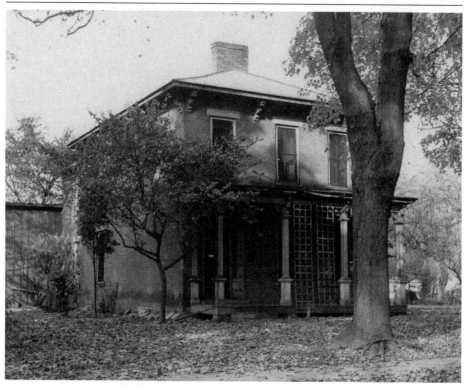

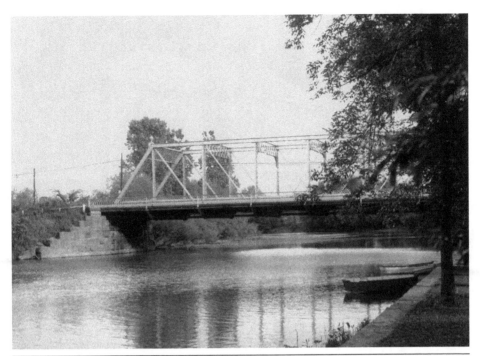

Prior to a bridge spanning Alum Creek, travelers with wagons were forced to wade through the creek at a low point near the end of Park Street. A covered bridge was constructed in 1856 and replaced in 1894 by a truss bridge. This iron bridge survived the 1913 flood and was in continuous use until 1969. As the 1969 concrete bridge began to fail, a new bridge, shown below, was opened on August 19, 2011, and is still in use.

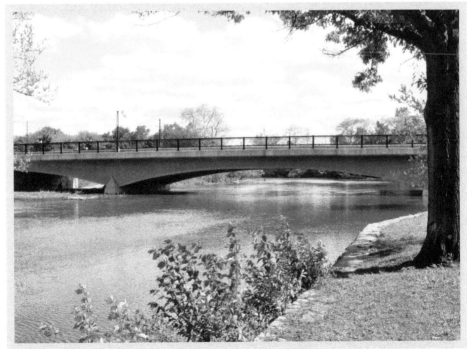

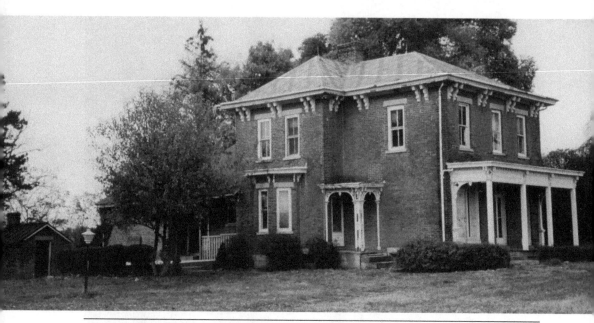

The Kiser House, more commonly known as the Rosselot house, was constructed around 1868 on the corner of State Route 3 and what is now Polaris Parkway; Bob Evans Restaurant and a retention pond now occupy the site. The 94-acre farm in which the house resided stood in the way of plans to develop the land, and in 1999 the house was sold and moved to its current location at 6938 Big Walnut Road.

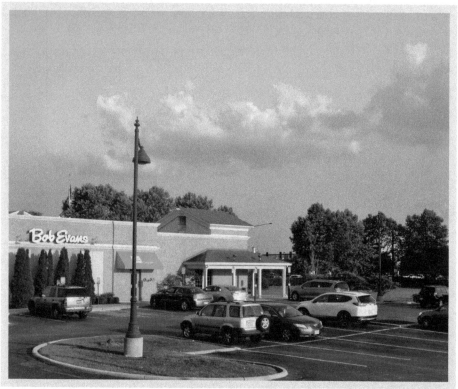

RESIDENTS, ROADWAYS, AND FARMING

This photograph was taken around the winter of 1908 at the intersection of State Route 3 and County Line Road (now Old County Line Road); the home of Garry Sharp can be seen in the center. Westerville citizens were a happy people and often referred to themselves as the "biggest little city in the United States." In 1919, the village was greatly honored by the visit of Gen. John Pershing's 115-piece marching band.

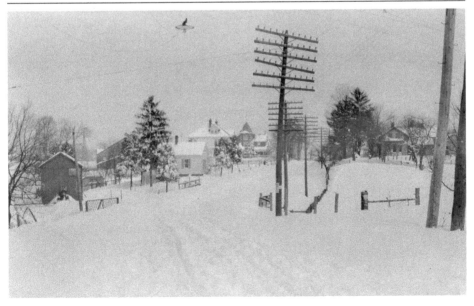

Visit us at
arcadiapublishing.com

CPSIA information can be obtained
at www.ICGtesting.com
Printed in the USA
BVHW051419150222
629076BV00004B/400